Brett Weston
Voyage of the Eye

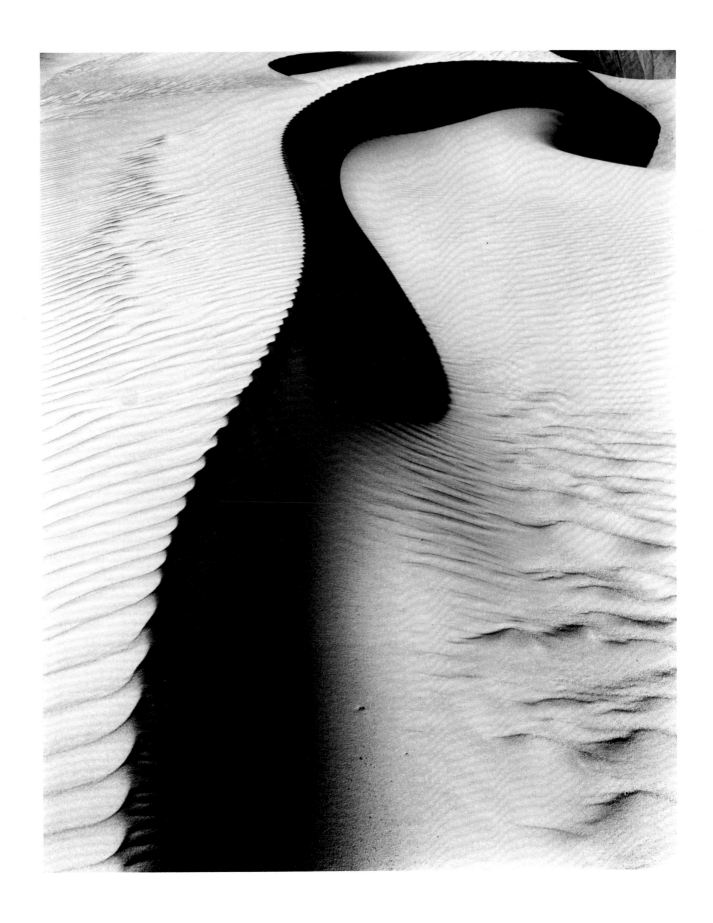

Dune, Oceano 1934

Brett Weston
Voyage of the Eye

Afterword by Beaumont Newhall

An Aperture Monograph

Dedication:

For my daughter Erica with love —

Warm thanks to Beaumont and Nancy Newhall
for endless hours spent in selecting the prints —
to Nancy for her title, and to
Beaumont for the foreword and arranging the
exhibit at the University of New Mexico, celebrating
my fiftieth year in photography.
Brett

Acknowledgments

The publisher wishes to thank Random House, Inc. for permission to reprint the passage from ''Cawdor'' by Robinson Jeffers from *The Selected Poetry of Robinson Jeffers*, and Liveright Publishing Corporation for permission to reprint ''Voyages'' by Hart Crane from *White Buildings*.

Brett Weston: *Voyage of the Eye*

Aperture, Inc., publishes a Quarterly of Photography, portfolios and books to communicate with serious photographers and creative people everywhere. A complete catalogue will be mailed upon request. Address: Elm Street, Millerton, New York 12546.

Published in the United States of America by Aperture, Inc., Elm Street, Millerton, New York 12546, and simultaneously in Canada by Gage Trade Publishing, Agincourt, Ontario, and in Great Britain by Gordon Fraser Gallery Limited, London, England.
Library of Congress Catalog Card Number: 75-13610
ISBN: Clothbound 0-912334-83-5
Paperbound 0-912334-84-3
Manufactured in the United States of America
Typography by Stephen Korbet
Printed by Rapoport Printing Corporation and
bound at Sendor Bindery
3 5 7 8 9 6 4 2
First Printing

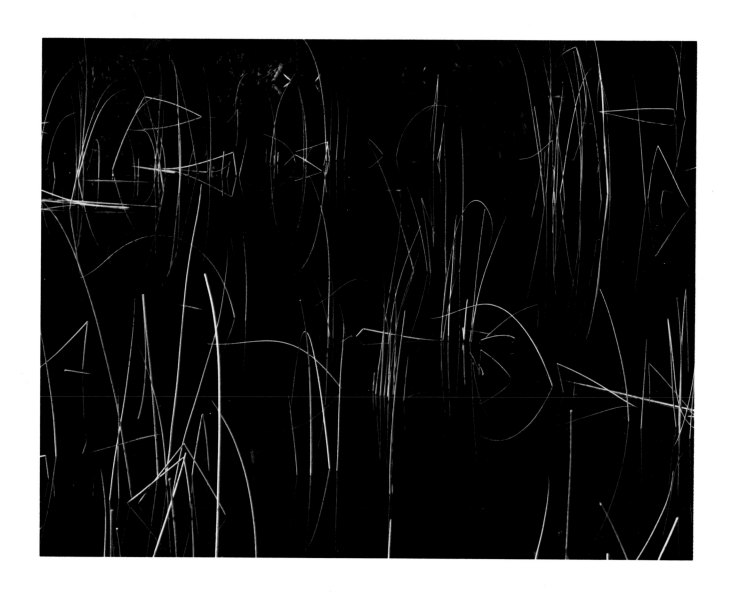

Reeds, Oregon

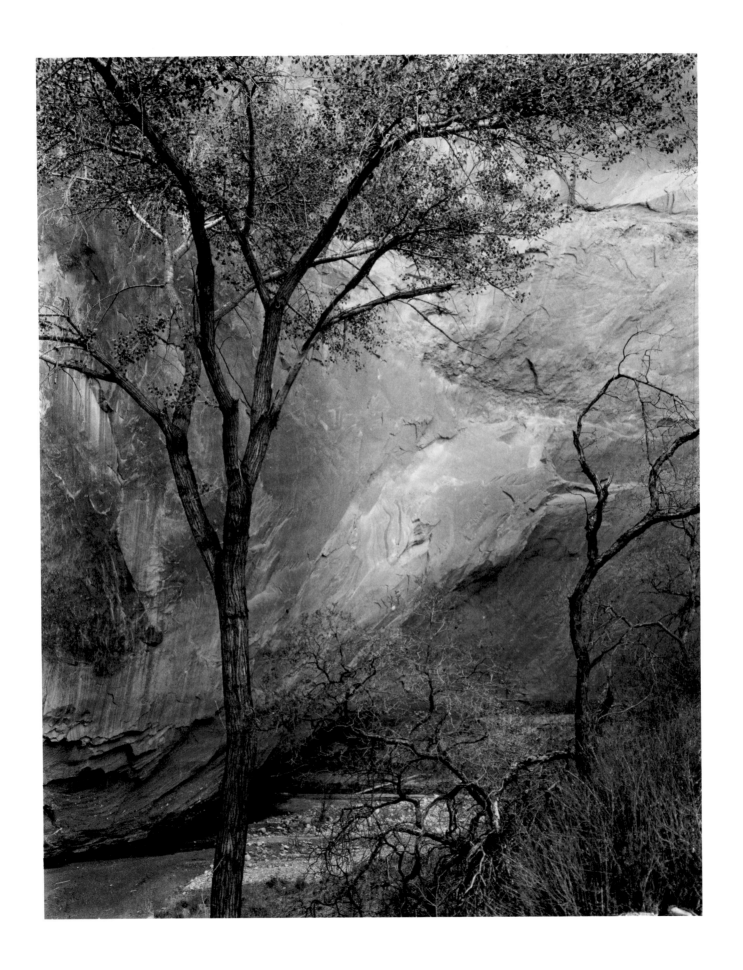

Glen Canyon 1959

Such is the constitution of all things, or
such the plastic power of the human eye,
that the primary forms, as the sky,
the mountain, the tree, the animal, give us a
delight in and for themselves; a pleasure
arising from outline, color, motion, and
grouping. This seems partly owing to the eye
itself. The eye is the best of artists.

Ralph Waldo Emerson,
from *Nature*

The beaked and winged effluence
Felt the air foam under its throat and saw
The mountain Sun-cup Tassajara, where fawns
Dance in the steam of hot mountains at dawn,
Smoothed-out, and the high strained ridges beyond Cachagua,
Where the mountains are born and the last condor is dead,
Flatten, and a hundred miles toward morning the Sierras
Dawn with their peaks of snow, and dwindle and smooth down
On the globed earth.

Robinson Jeffers
from *Cawdor*

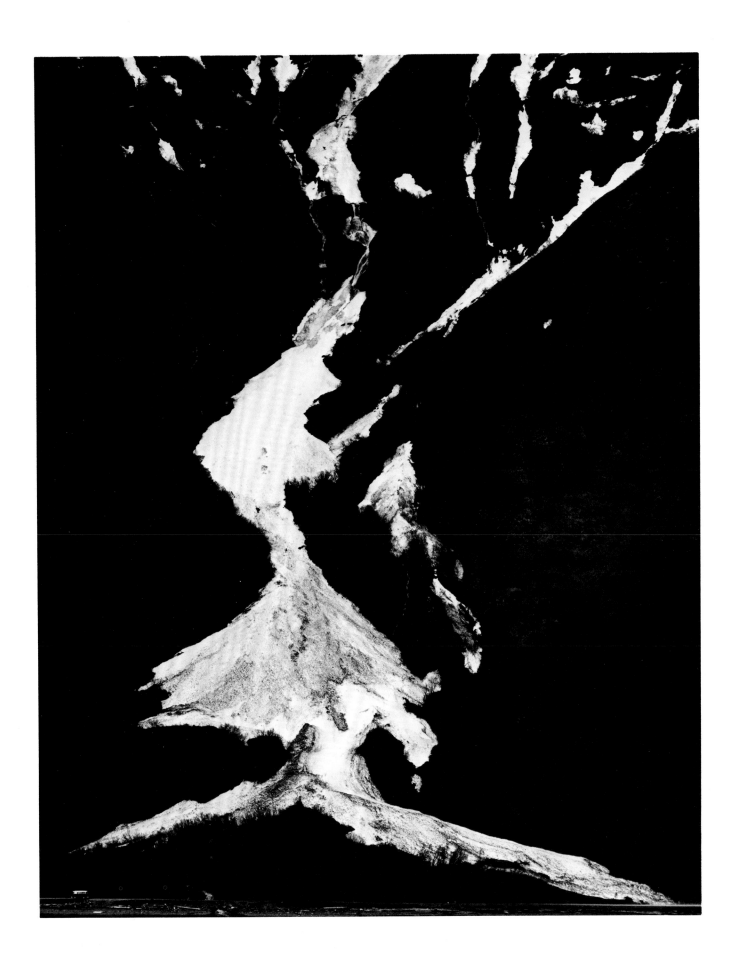

Snow Slide, Alaska 1973

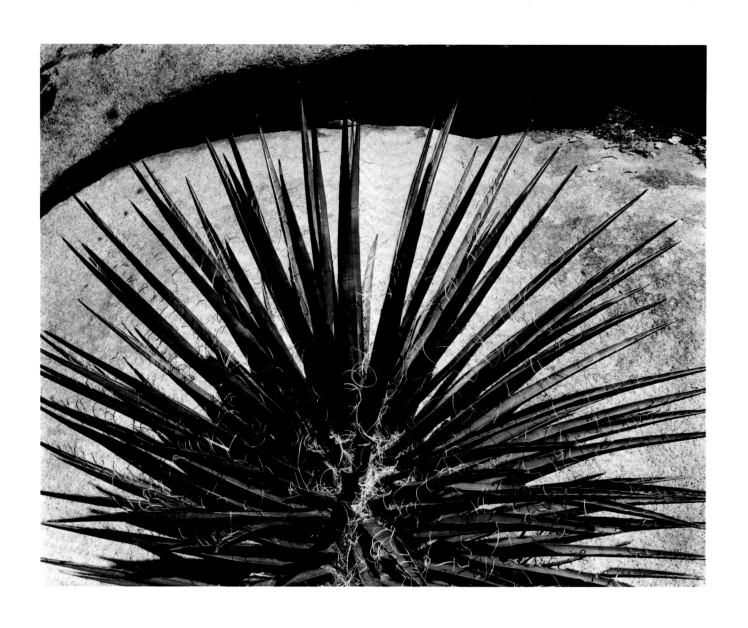

Yucca 1968

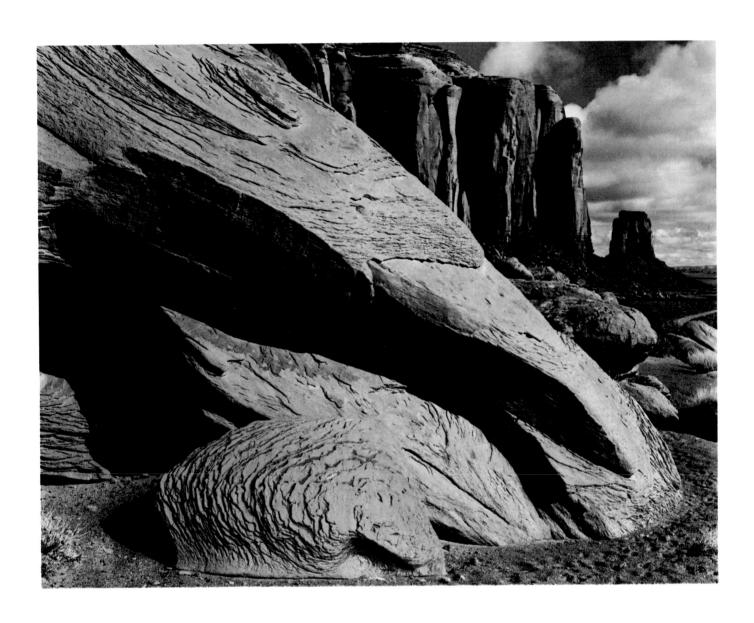

Monument Valley 1971

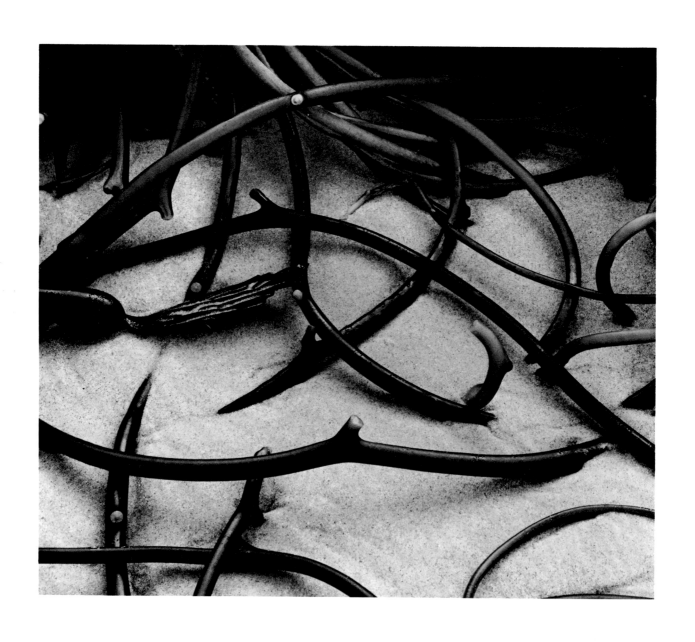

Kelp, Carmel 1969

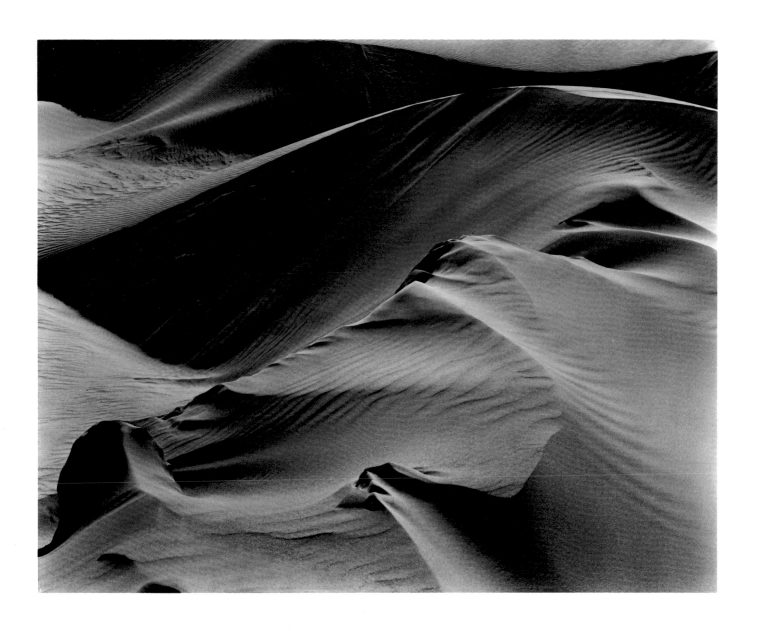

Dunes, White Sands 1950

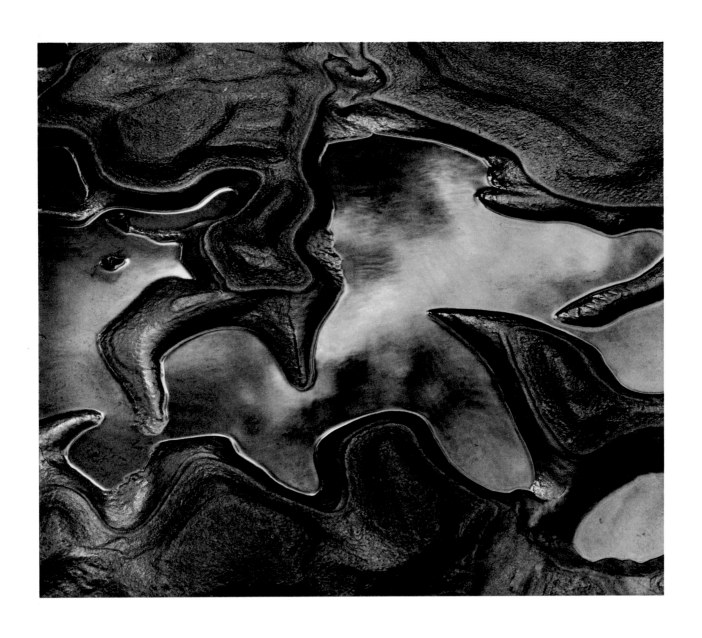

Glacial Silt, Alaska 1973

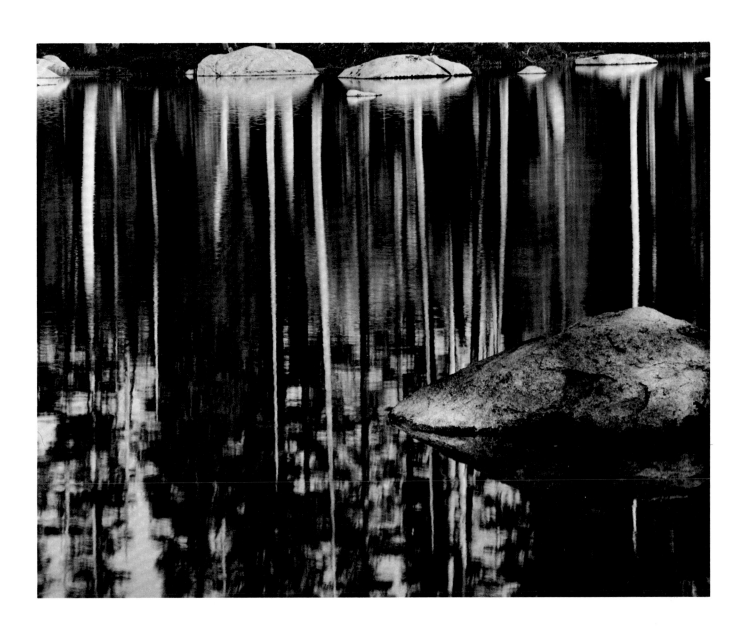

Pond and Conifers, High Sierra 1972

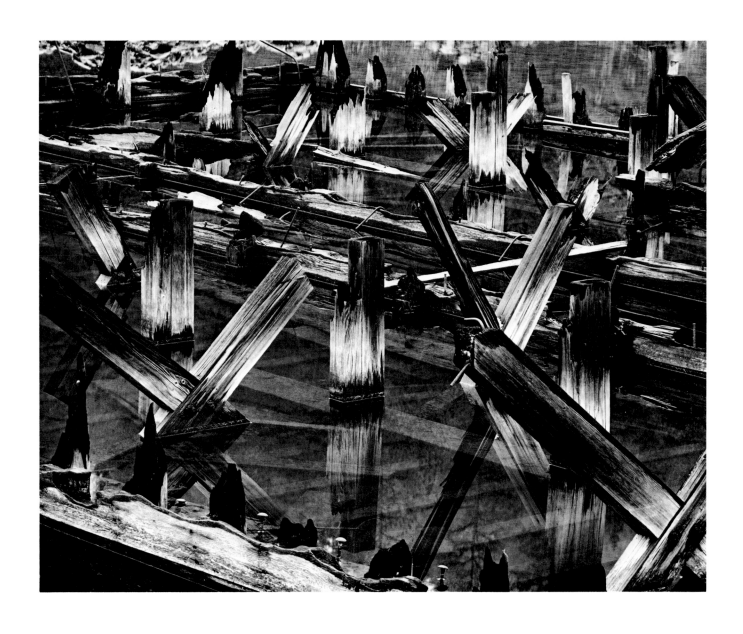

Burnt Wharf, Oregon 1972

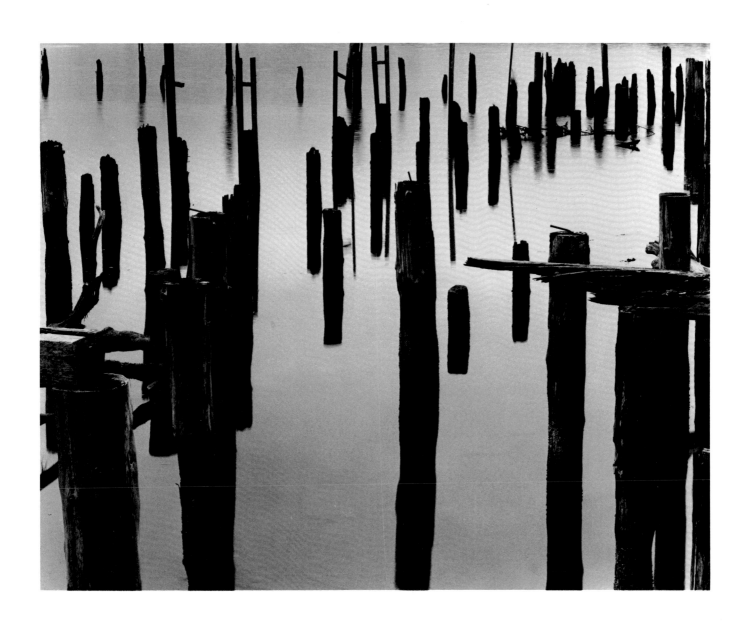

Wharf Piles and Fog, Oregon 1968

Voyages

by Hart Crane

I

Above the fresh ruffles of the surf
Bright striped urchins flay each other with sand.
They have contrived a conquest for shell shucks,
And their fingers crumble fragments of baked
 weed
Gaily digging and scattering.

And in answer to their treble interjections
The sun beats lightning on the waves,
The waves fold thunder on the sand;
And could they hear me I would tell them:

O brilliant kids, frisk with your dog,
Fondle your shells and sticks, bleached
By time and the elements; but there is a line
You must not cross nor ever trust beyond it
Spry cordage of your bodies to caresses
Too lichen-faithful from too wide a breast.
The bottom of the sea is cruel.

The Desert

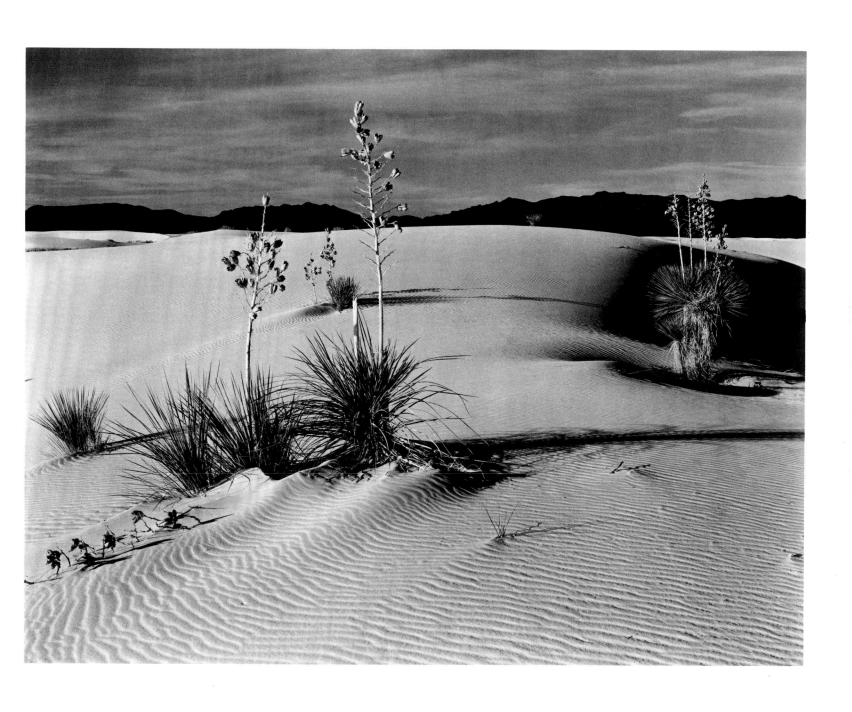

Yucca and Black Mountains, White Sands 1945

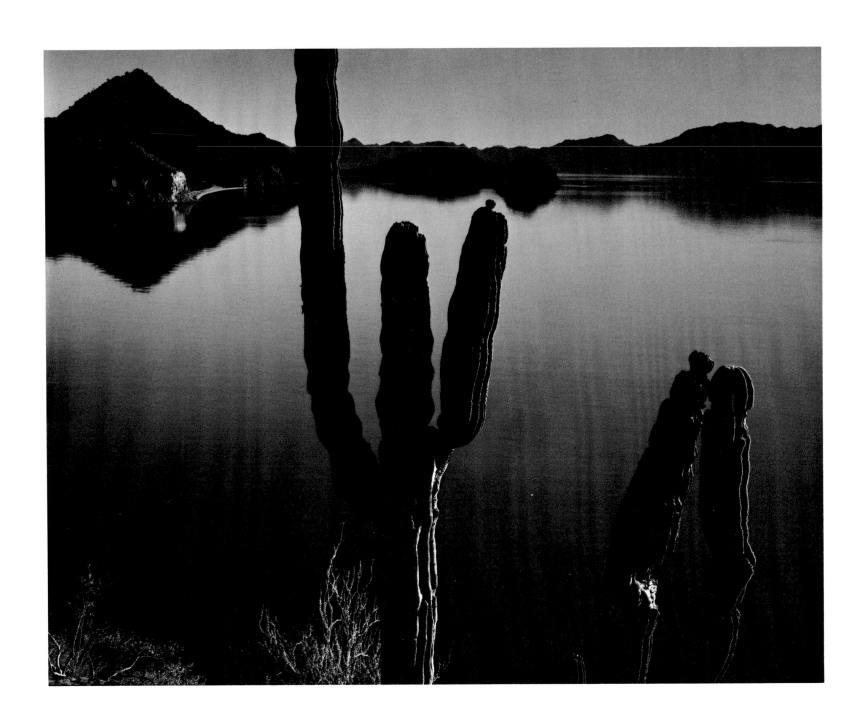

Cardons and Bay, Baja California 1966

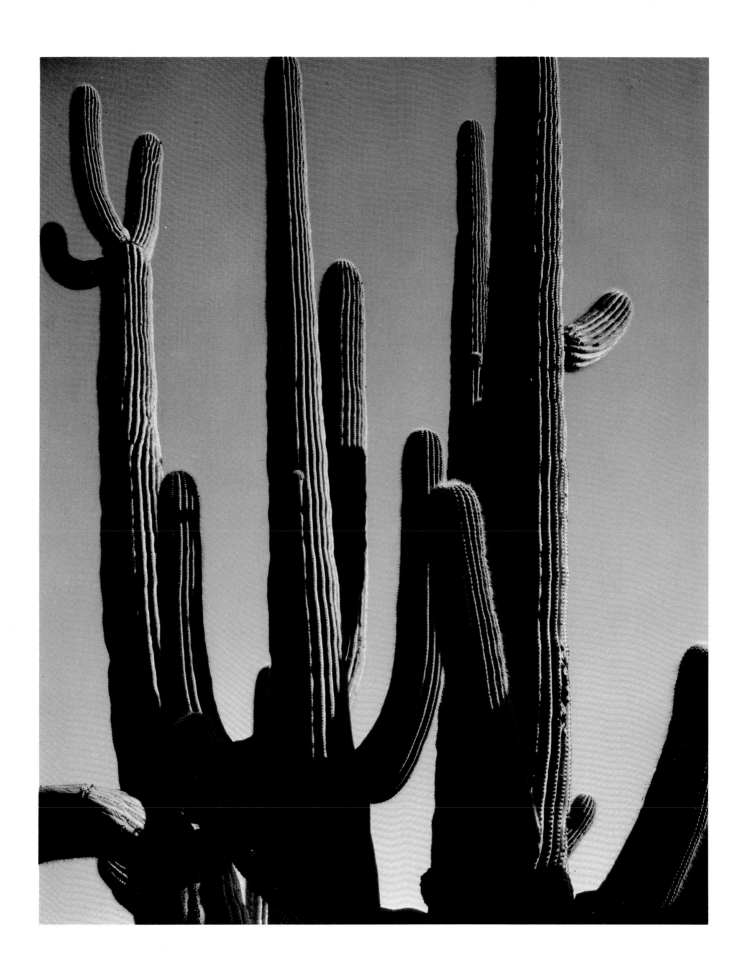

Saguaros, Arizona 1968

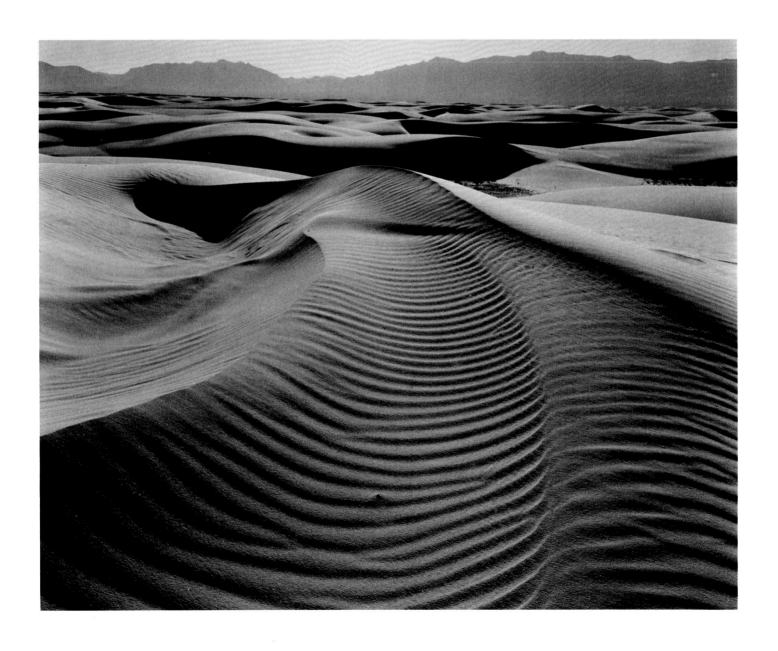

Dunes and Mountains, White Sands 1945

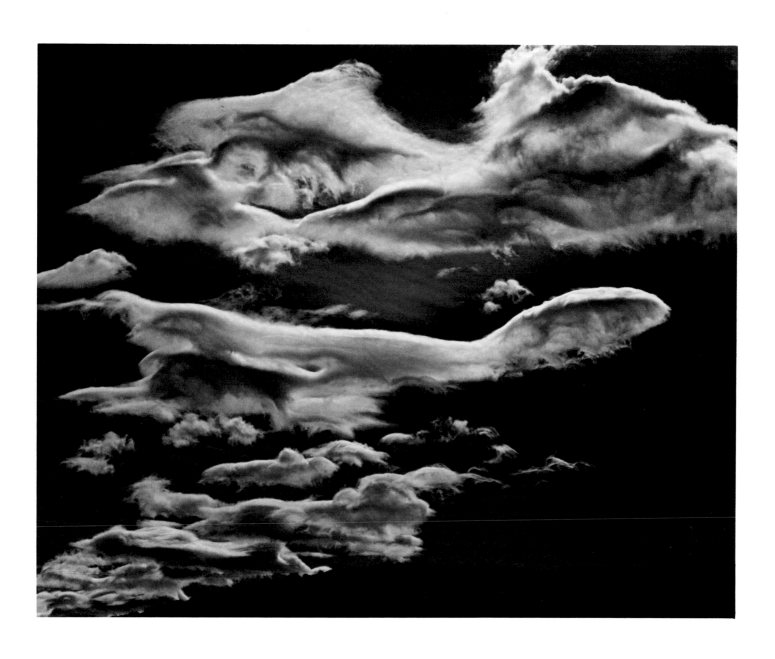

Clouds, Owens Valley 1968

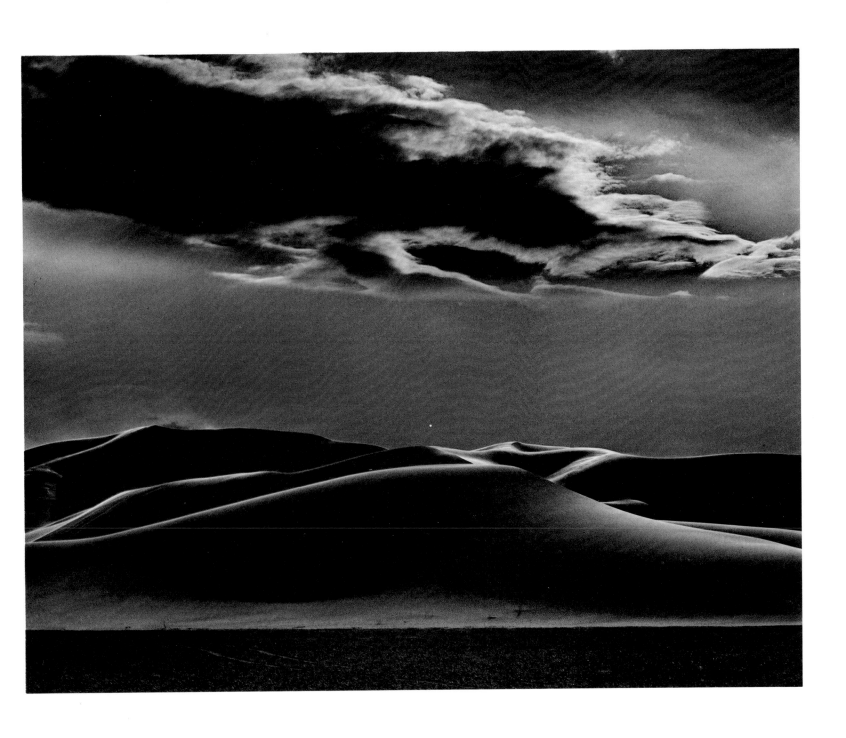

Dunes and Clouds, Shoshone 1969

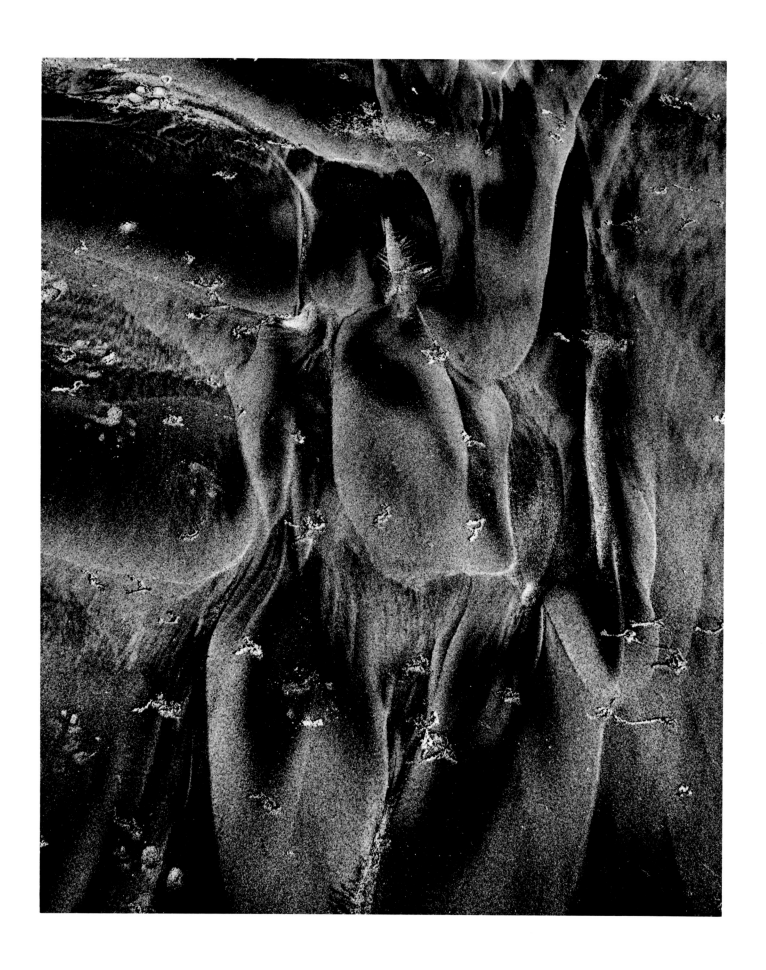

Sand Patterns, Baja 1967

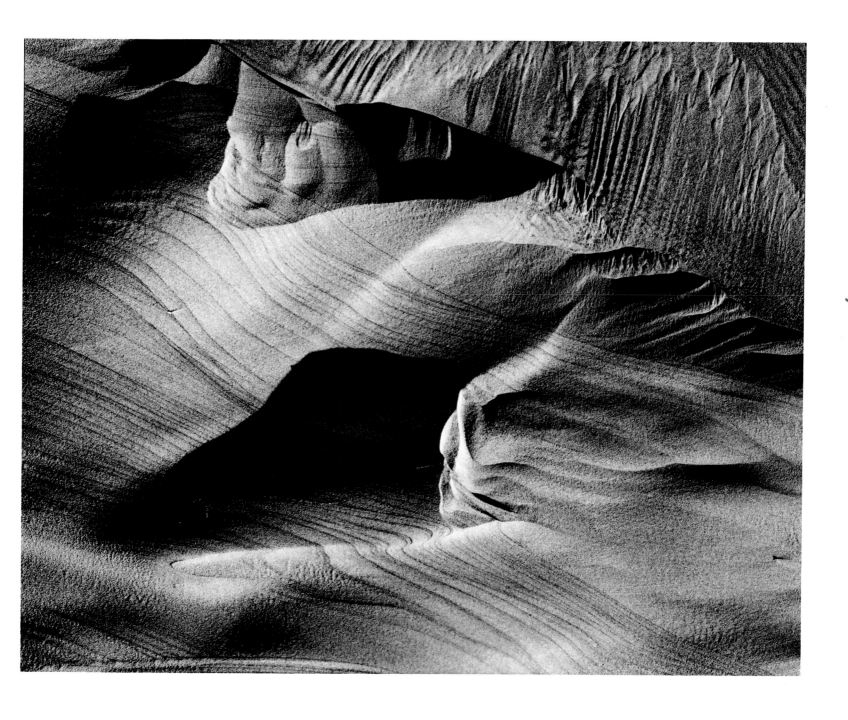

Dunes, Baja 1967

New York, 1944–1945

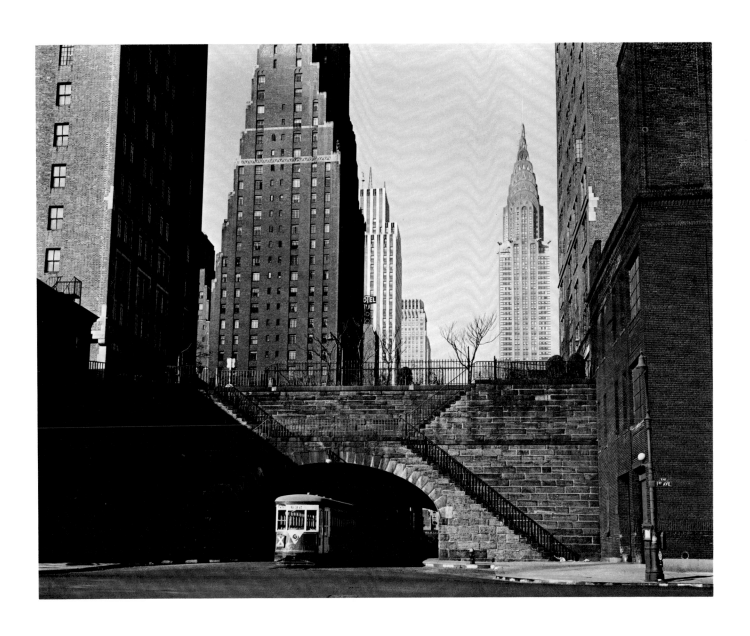

East 42nd Street 1945

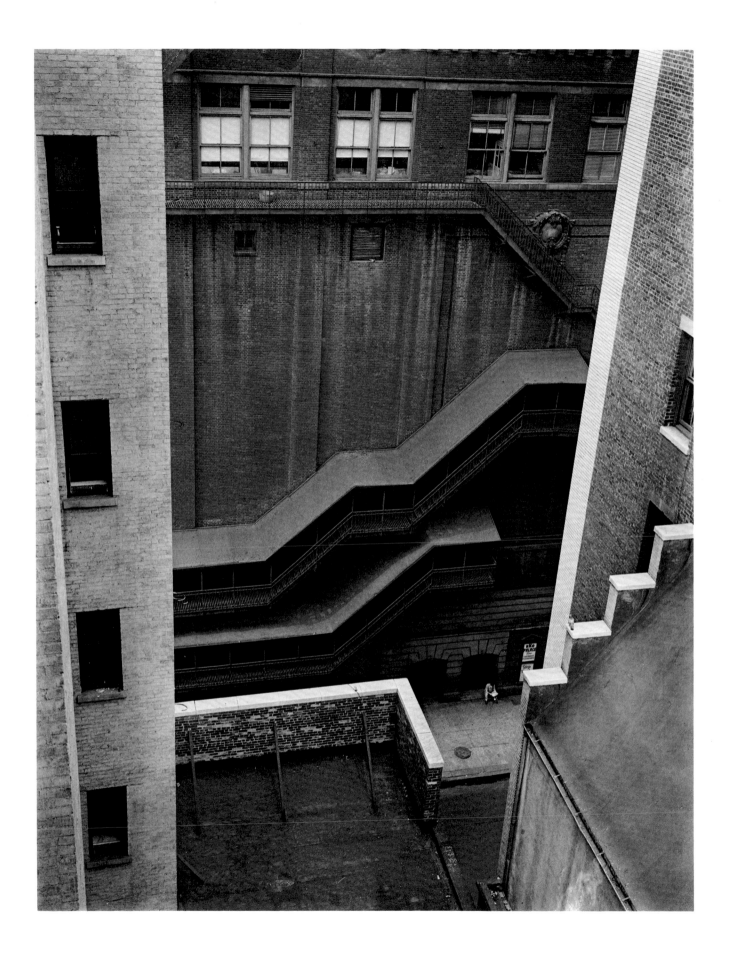

47th Street 1945

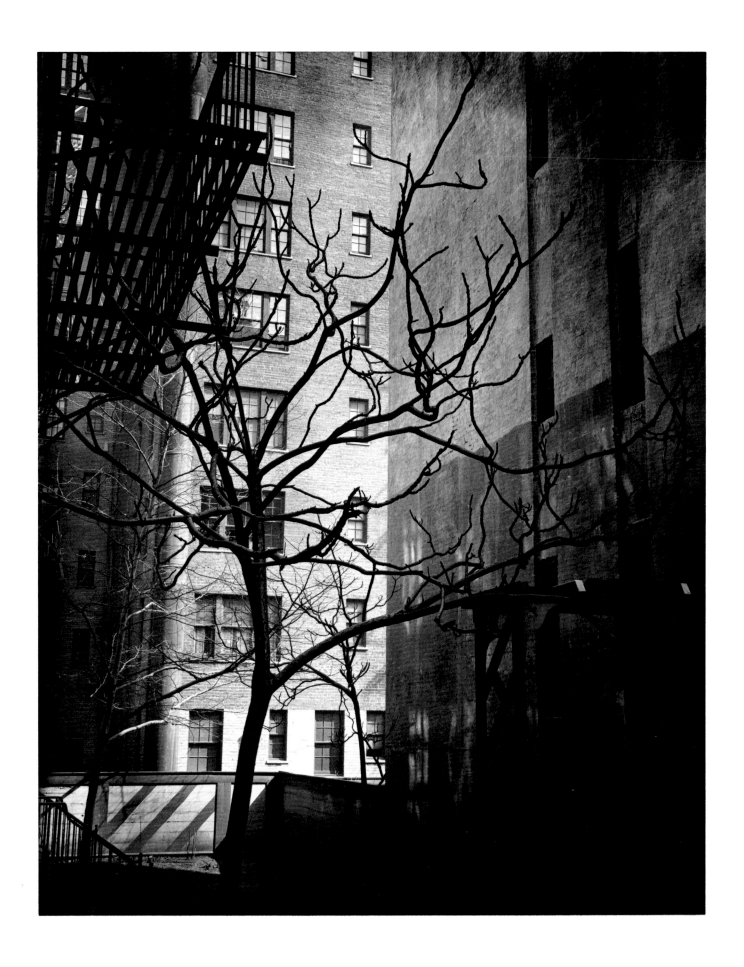

Manhattan Courtyard 1945

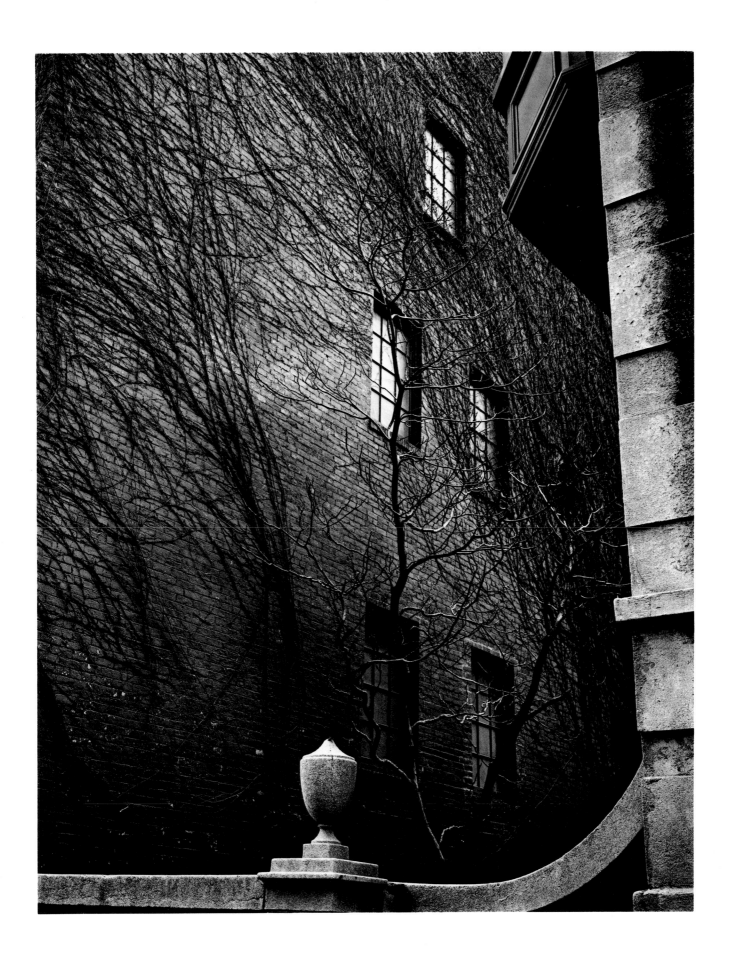

Sutton Place 1945

II

—And yet this great wink of eternity,
Of rimless floods, unfettered leewardings,
Samite sheeted and processioned where
Her undinal vast belly moonward bends,
Laughing the wrapt inflections of our love;

Take this Sea, whose diapason knells
On scrolls of silver snowy sentences,
The sceptred terror of whose sessions rends
As her demeanors motion well or ill,
All but the pieties of lovers' hands.

And onward, as bells off San Salvador
Salute the crocus lustres of the stars,
In these poinsettia meadows of her tides,—
Adagios of islands, O my Prodigal,
Complete the dark confessions her veins spell.

Mark how her turning shoulders wind the hours,
And hasten while her penniless rich palms
Pass superscription of bent foam and wave,—
Hasten, while they are true,—sleep, death, desire,
Close round one instant in one floating flower.

Bind us in time, O Seasons clear, and awe.
O minstrel galleons of Carib fire,
Bequeath us to no earthly shore until
Is answered in the vortex of our grave
The seal's wide spindrift gaze toward paradise.

California Beaches

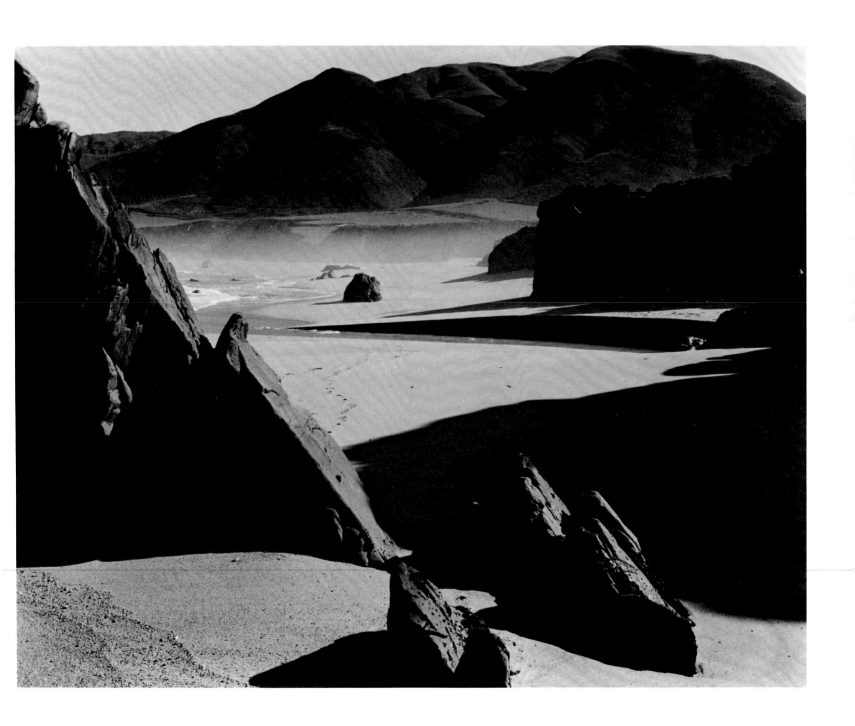

Garapata Beach 1954

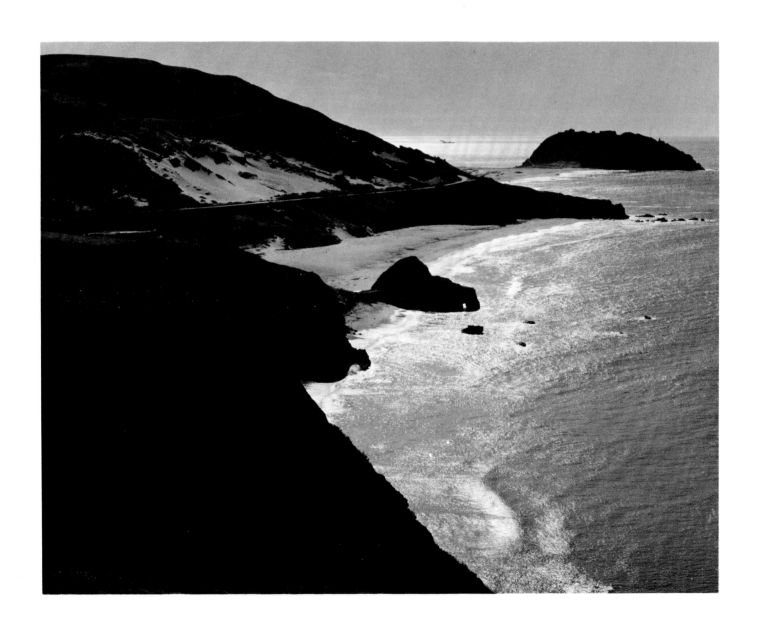

Big Sur, Fog 1966

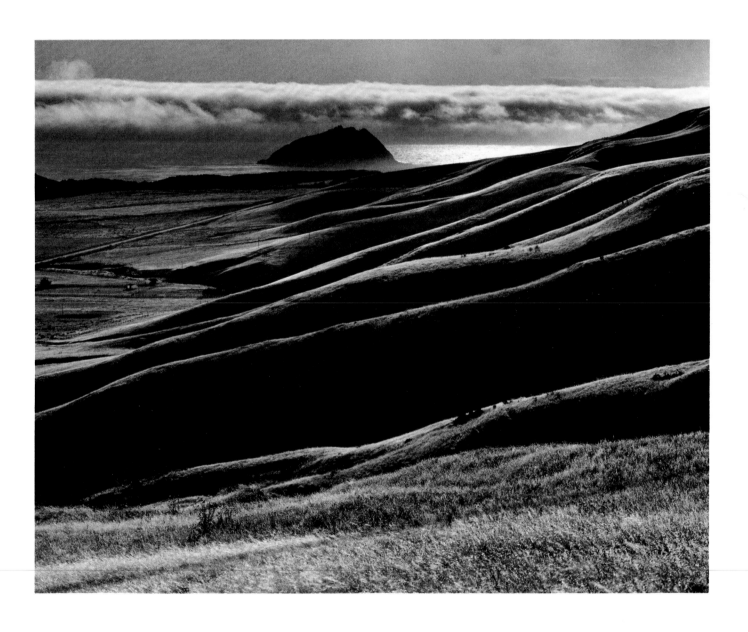

Point Sur and Fog Bank 1964

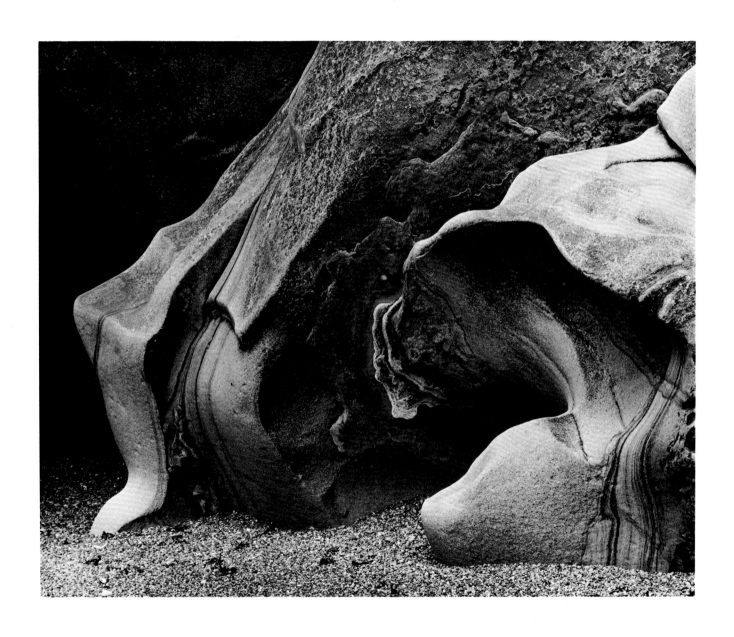

Rock Forms, Point Lobos 1970

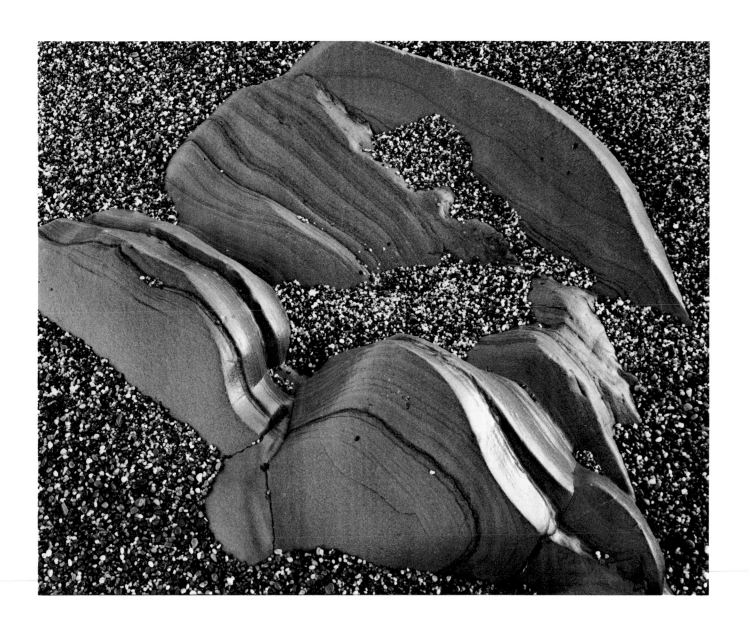

Eroded Rocks, Pebble Beach 1966

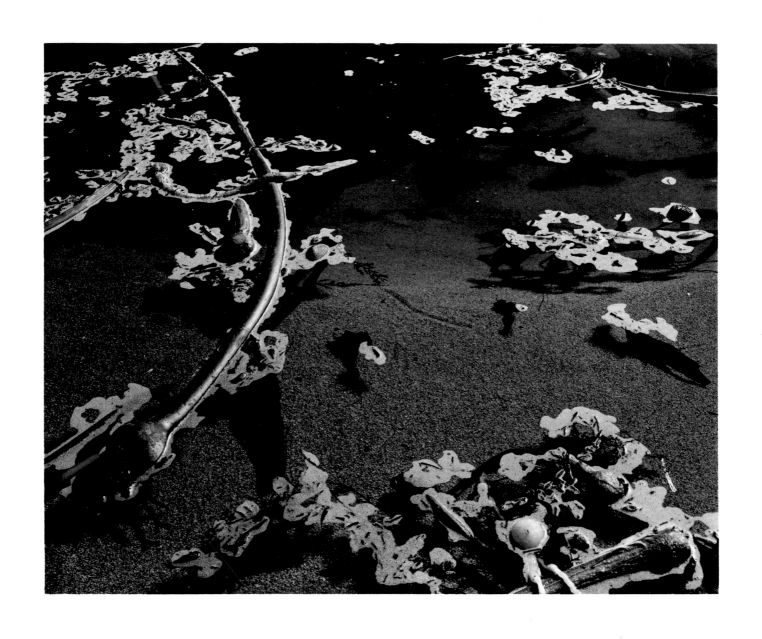

Tide Pool 1952

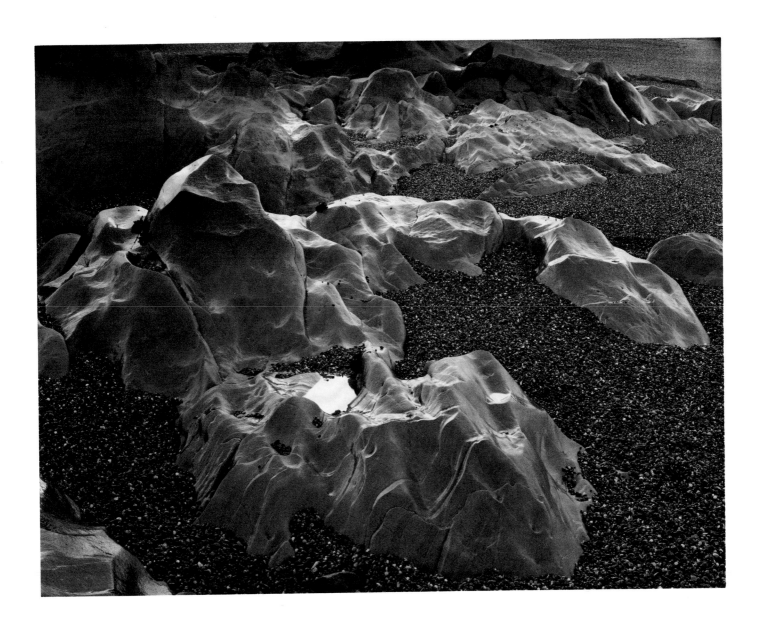

Rock Forms with Tide Pool, Pebble Beach 1968

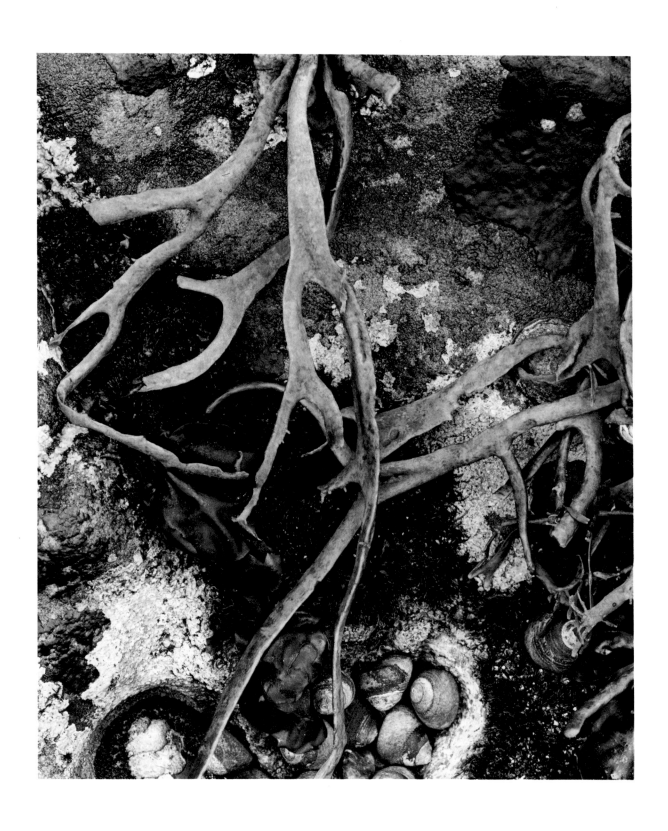

Tide Pool, Anaenomes and Hermit Crabs 1969

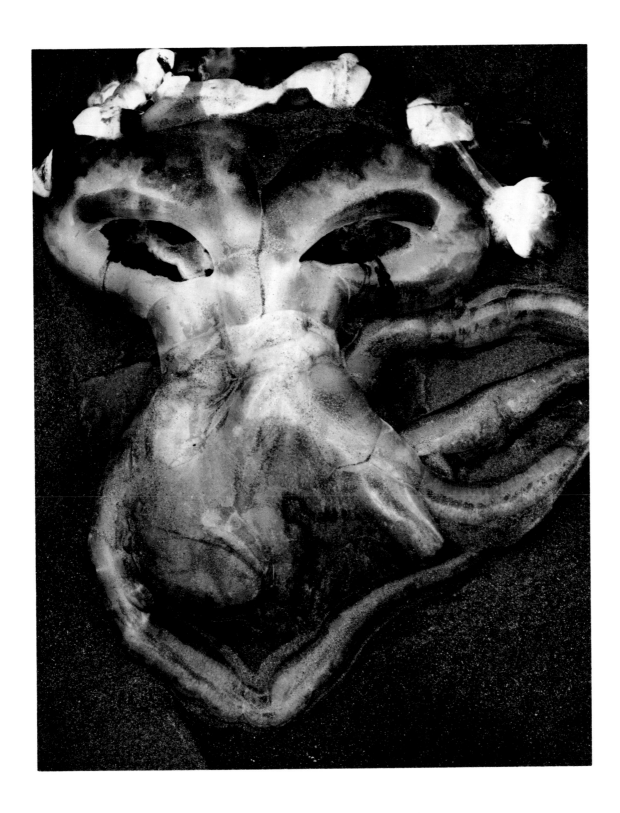

Dead Jelly Fish 1967

III

Infinite consanguinity it bears—
This tendered theme of you that light
Retrieves from sea plains where the sky
Resigns a breast that every wave enthrones;
While ribboned water lanes I wind
Are laved and scattered with no stroke
Wide from your side, whereto this hour
The sea lifts, also, reliquary hands.

And so, admitted through black swollen gates
That must arrest all distance otherwise,—
Past whirling pillars and lithe pediments,
Light wrestling there incessantly with light,
Star kissing star through wave on wave unto
Your body rocking
 and where death, if shed,
Presumes no carnage, but this single change,—
Upon the steep floor flung from dawn to dawn
The silken skilled transmemberment of song;

Permit me voyage, love, into your hands . . .

Europe

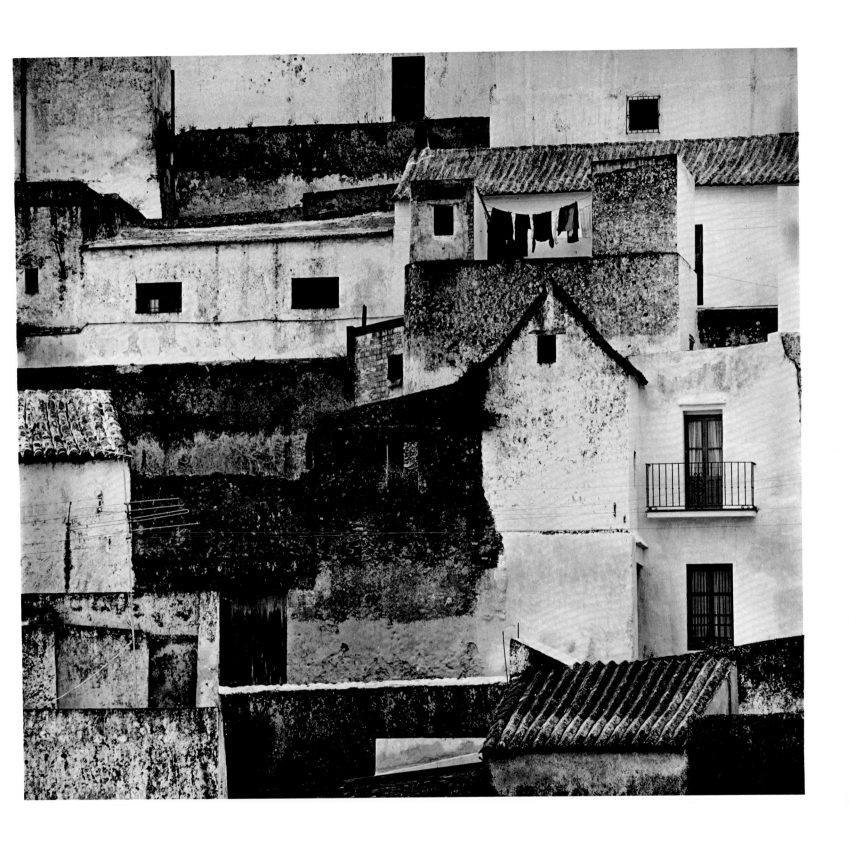

Village Spain 1971

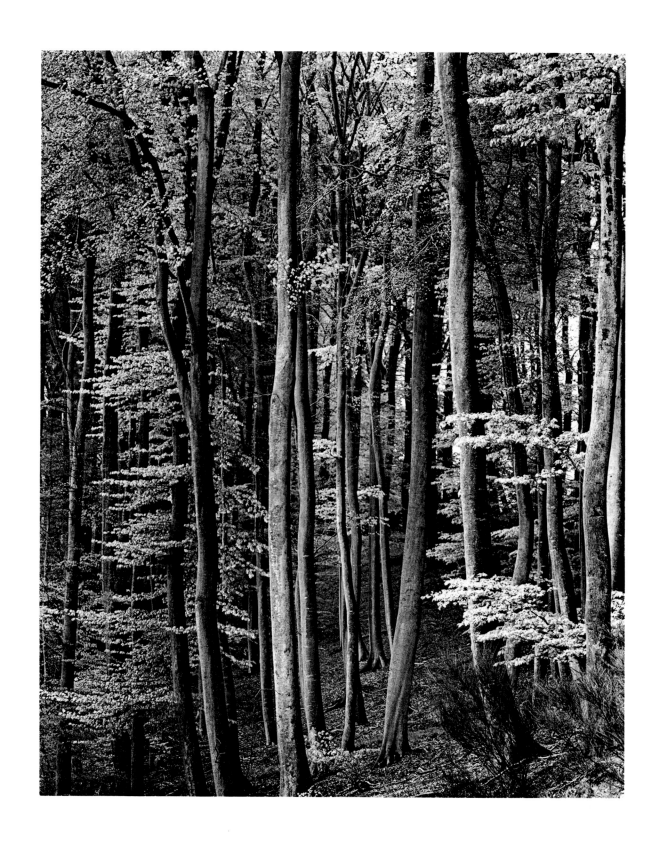

Beech Forest, Luxembourg 1971

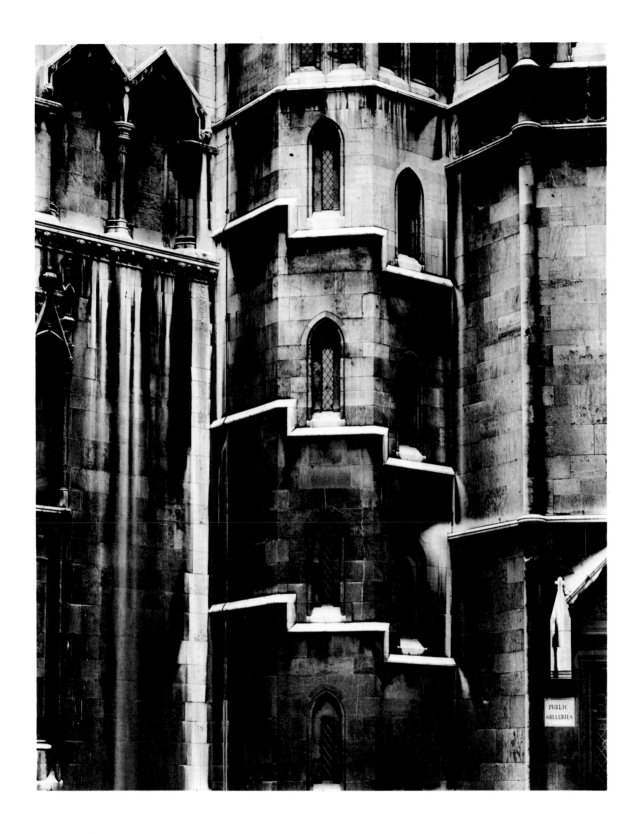

London

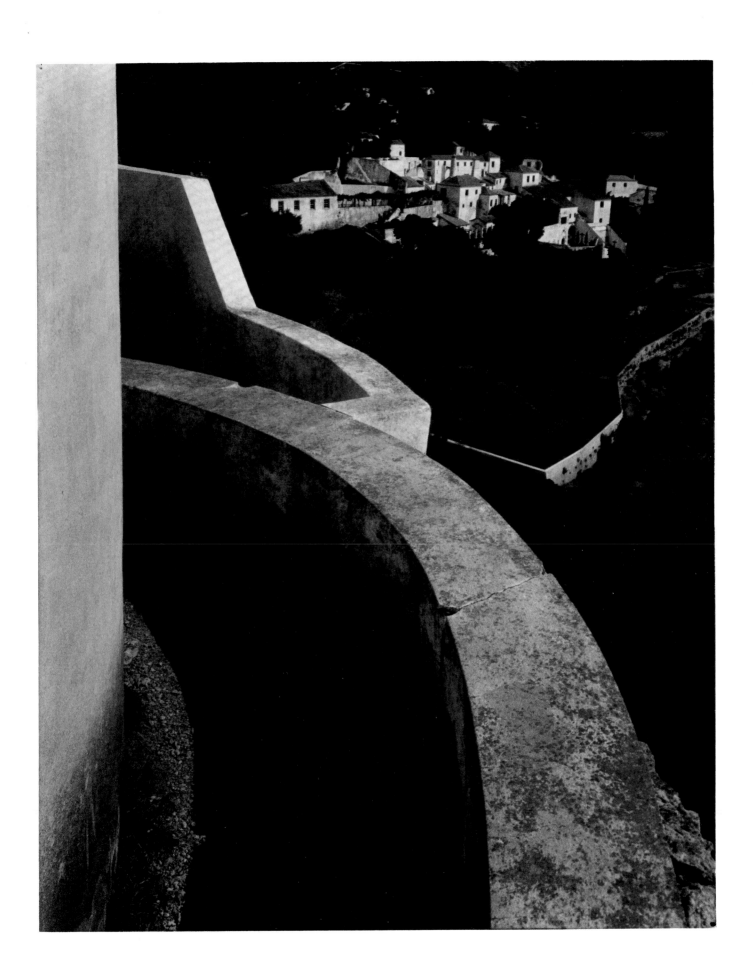

Monastery, Portugal 1960

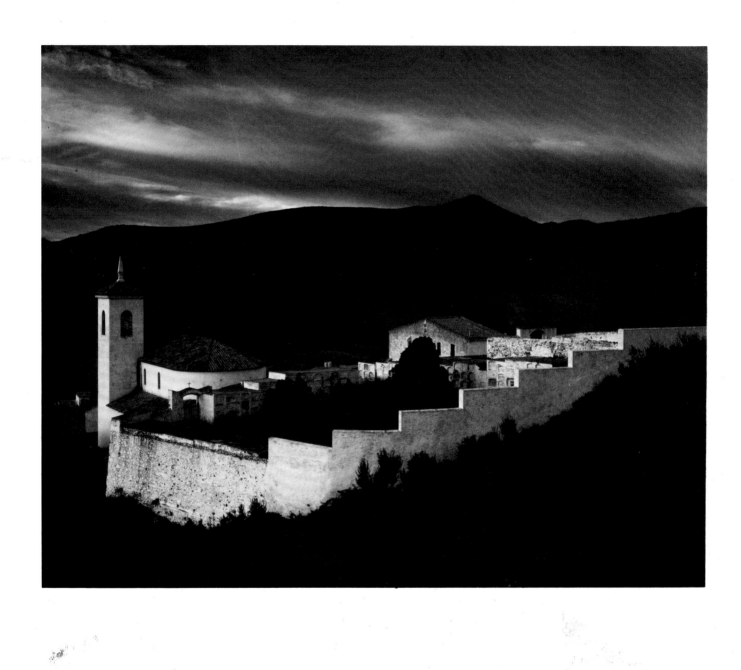

Chapel and Cemetery, Spain 1960

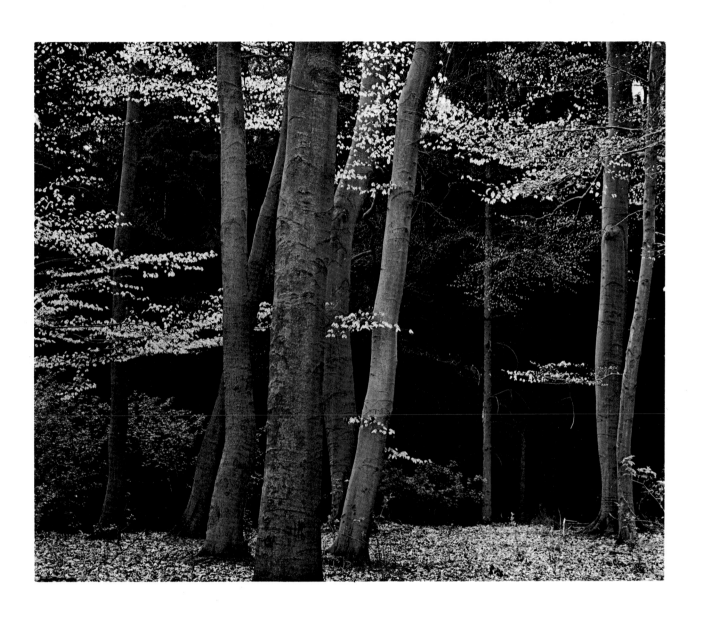

Beech Forest, The Netherlands 1971

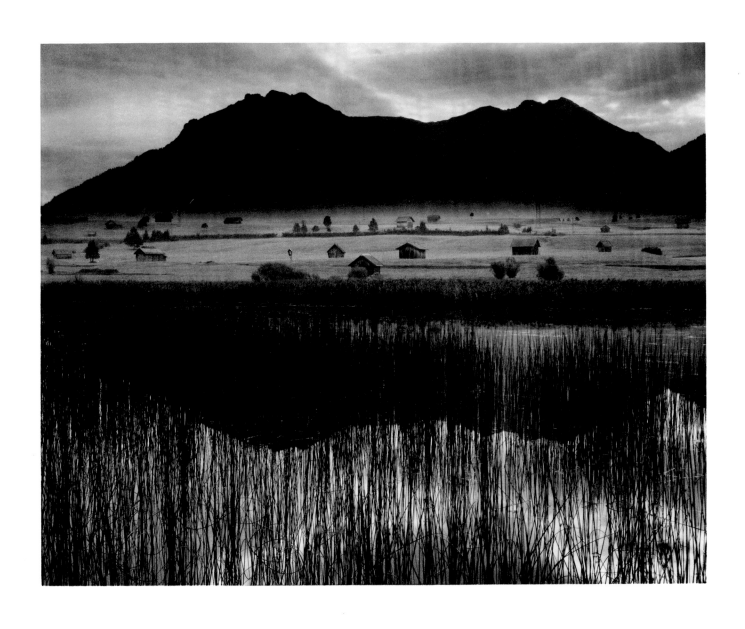

Landscape, Germany 1960

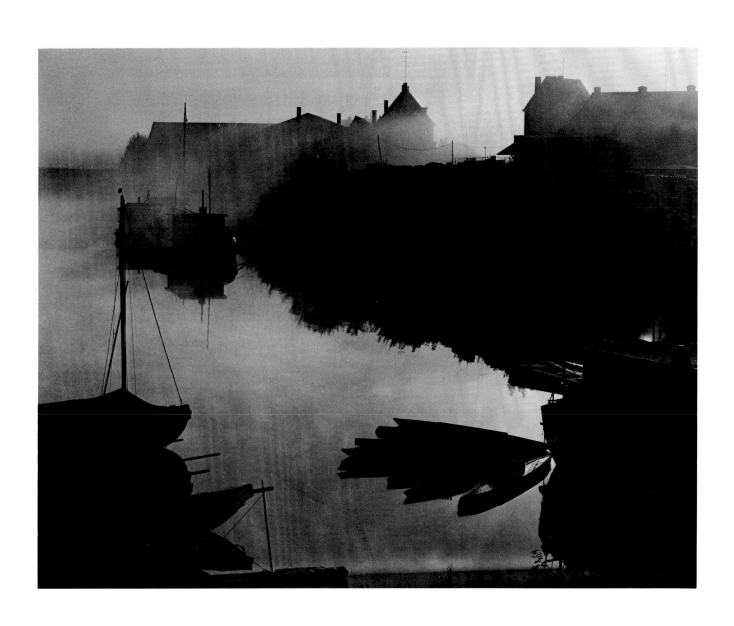

Harbor, The Netherlands 1960

IV

Whose counted smile of hours and days, suppose
I know as spectrum of the sea and pledge
Vastly now parting gulf on gulf of wings
Whose circles bridge, I know, (from palms to the
 severe
Chilled albatross's white immutability)
No stream of greater love advancing now
Than, singing, this mortality alone
Through clay aflow immortally to you.

All fragrance irrefragibly, and claim
Madly meeting logically in this hour
And region that is ours to wreathe again,
Portending eyes and lips and making told
The chancel port and portion of our June—

Shall they not stem and close in our own steps
Bright staves of flowers and quills to-day as I
Must first be lost in fatal tides to tell?

In signature of the incarnate word
The harbor shoulders to resign in mingling
Mutual blood, transpiring as foreknown
And widening noon within your breast for
 gathering
All bright insinuations that my years have caught
For islands where must lead inviolably
Blue latitudes and levels of your eyes,—

In this expectant, still exclaim receive
The secret oar and petals of all love.

Japan, 1970

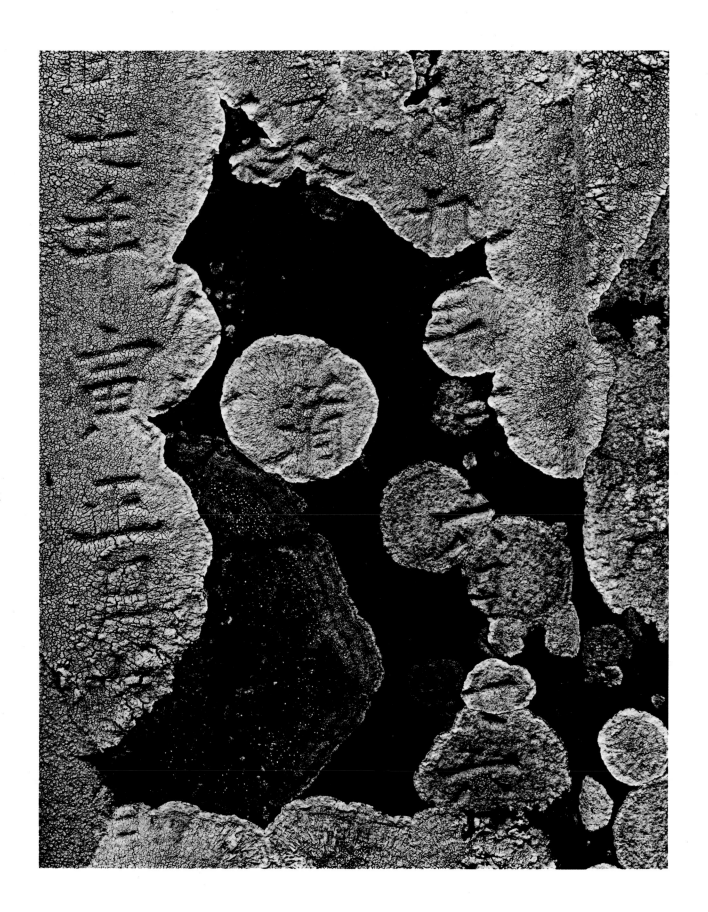

Headstone and Lichen

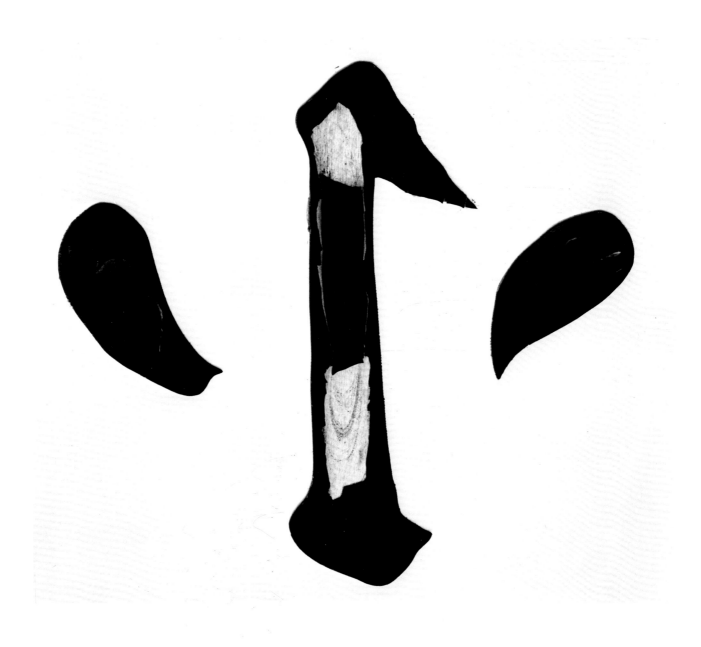

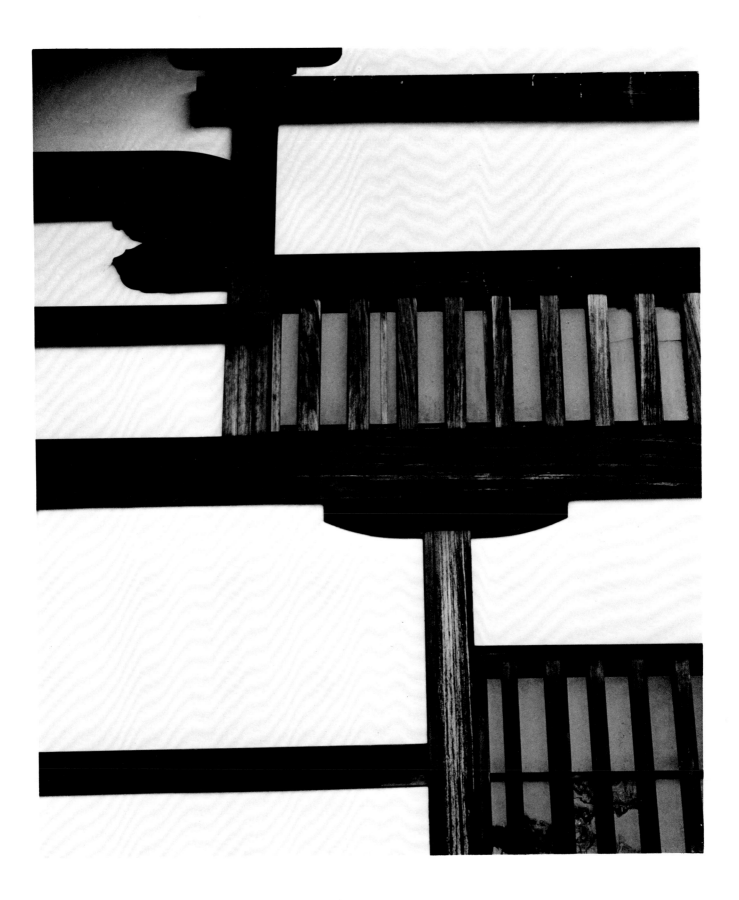

Temple Facade

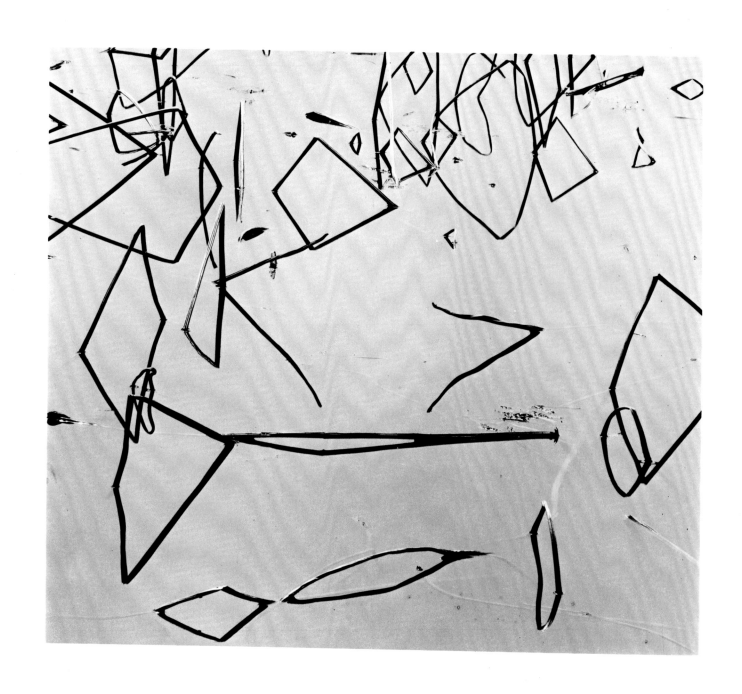

Reeds and Pond

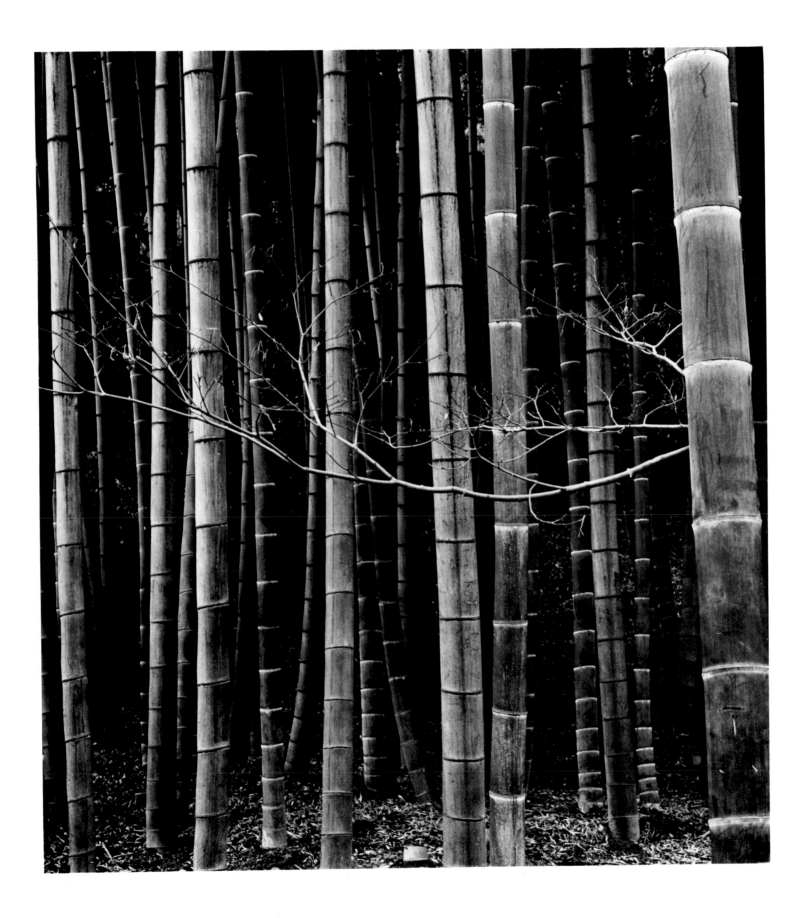

Bamboo Forest

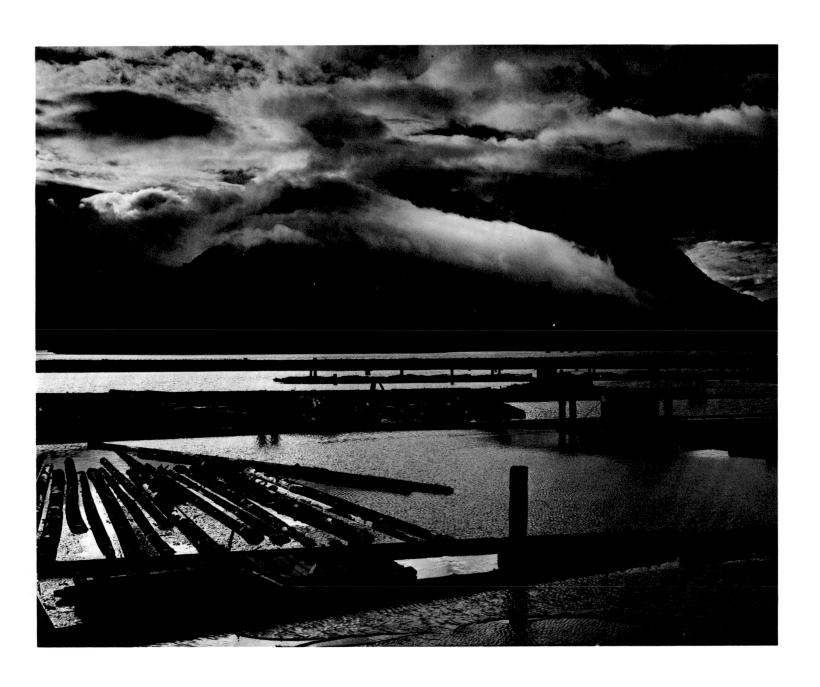

Vancouver Island 1973

Alaska, 1973

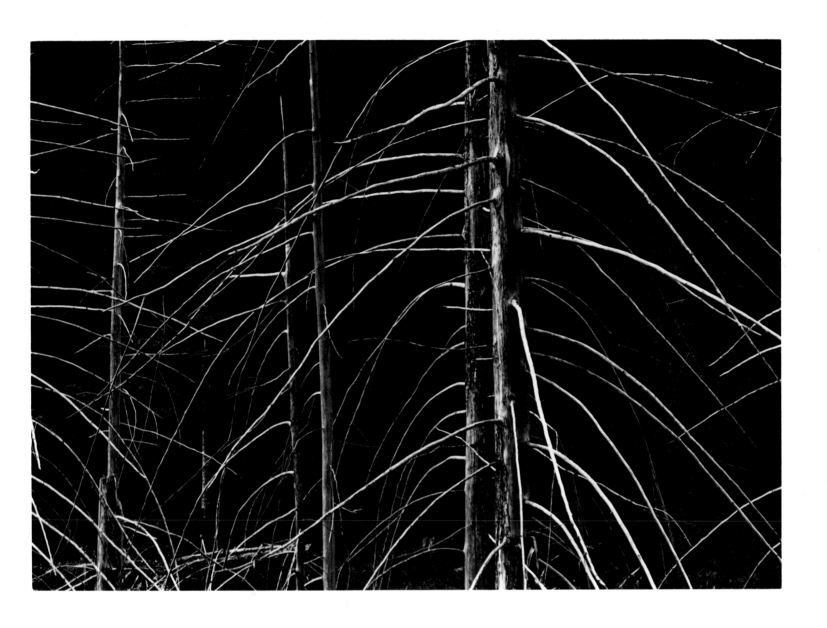

Forest, Dead and Burnt

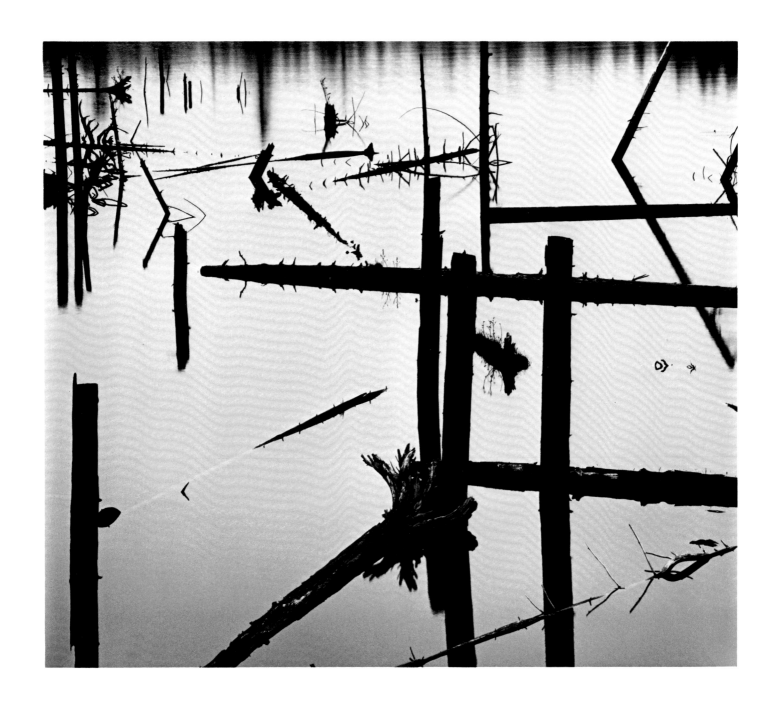

Logging Pond

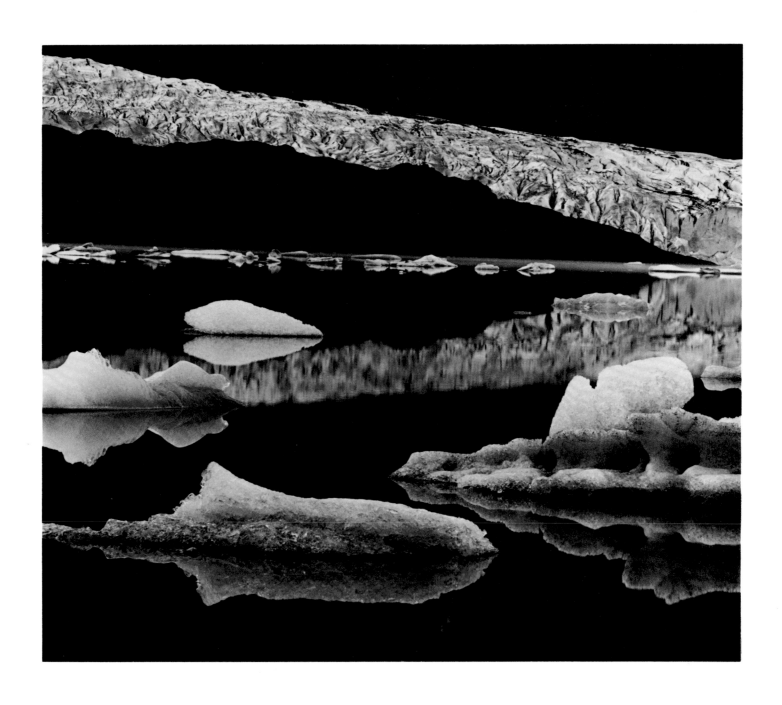

Mendenhall Glacier

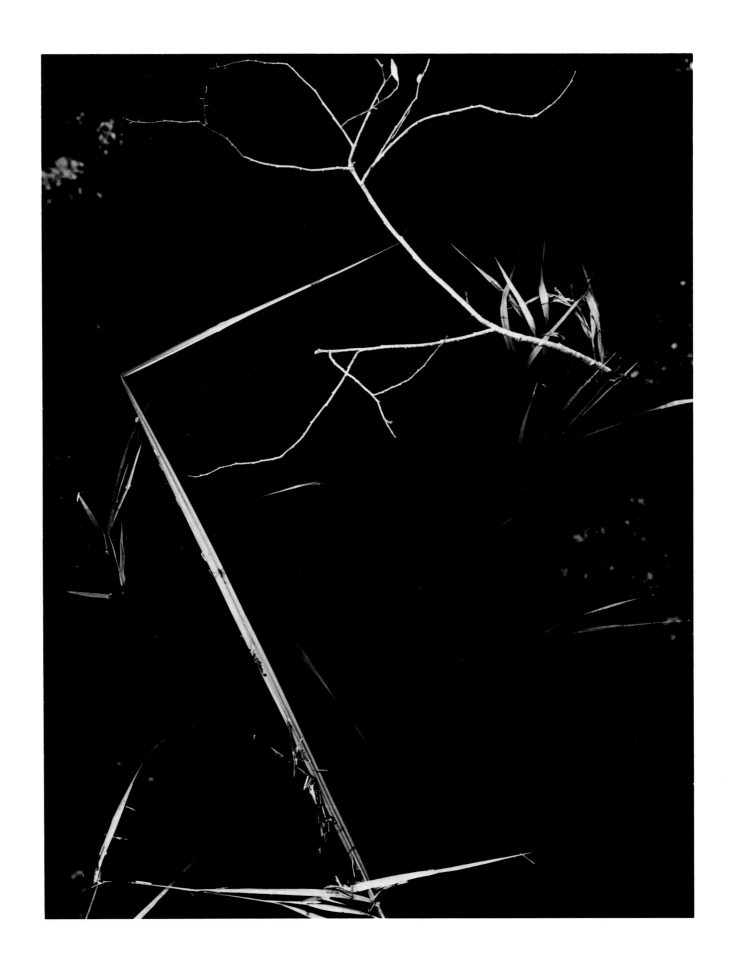

Swamp Grasses

V

Meticulous, past midnight in clear rime,
Infrangible and lonely, smooth as though cast
Together in one merciless white blade—
The bay estuaries fleck the hard sky limits.

—As if too brittle or too clear to touch!
The cables of our sleep so swiftly filed,
Already hang, shred ends from remembered stars.
One frozen trackless smile. . . What words
Can strangle this deaf moonlight? For we

Are overtaken. Now no cry, no sword
Can fasten or deflect this tidal wedge,
Slow tyranny of moonlight, moonlight loved
And changed . . . ''There's

Nothing like this in the world,'' you say,
Knowing I cannot touch your hand and look
Too, into that godless cleft of sky
Where nothing turns but dead sands flashing.

''—And never to quite understand!'' No,
In all the argosy of your bright hair I dreamed
Nothing so flagless as this piracy.

 But now
Draw in your head, alone and too tall here.
Your eyes already in the slant of drifting foam;
Your breath sealed by the ghosts I do not know:
Draw in your head and sleep the long way home.

Abstractions

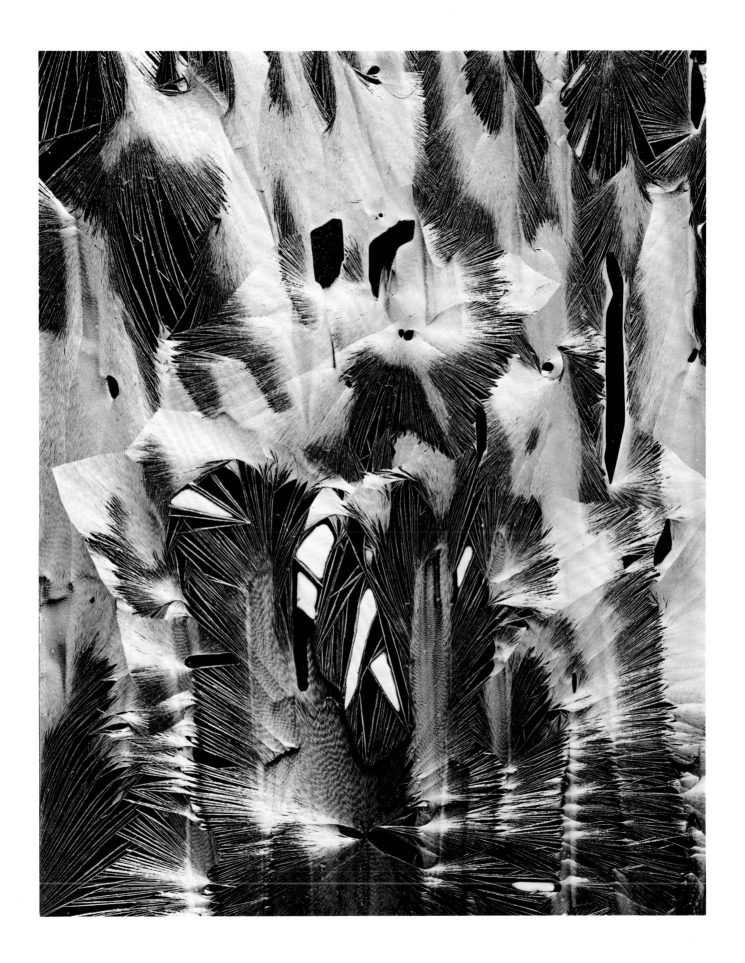

Cracked Paint 1955

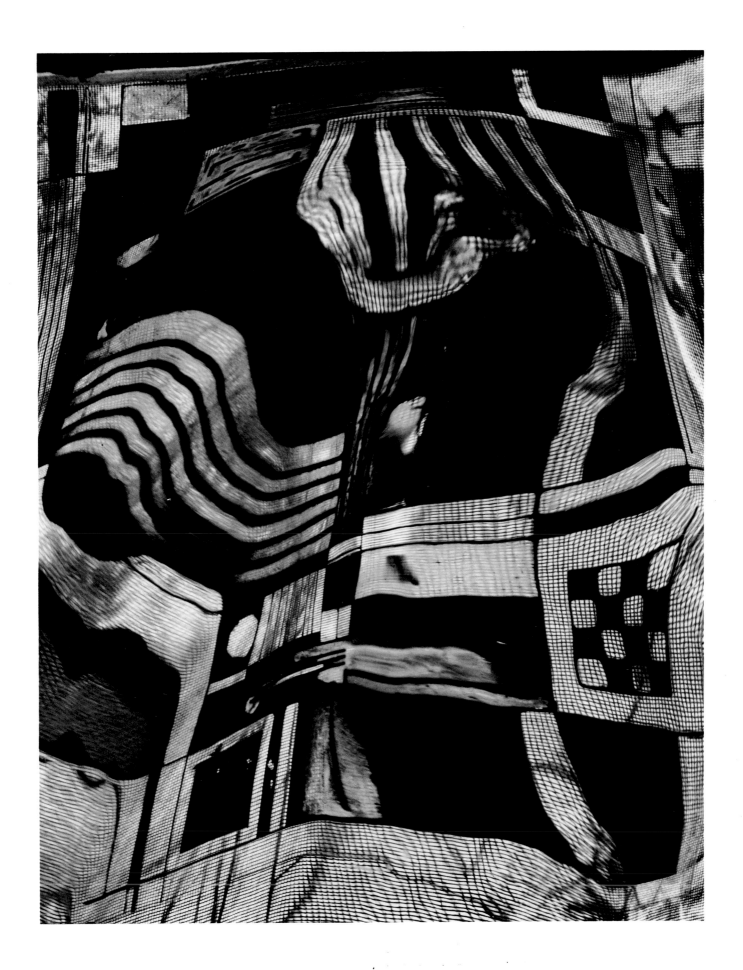

Reflections through Window 1954

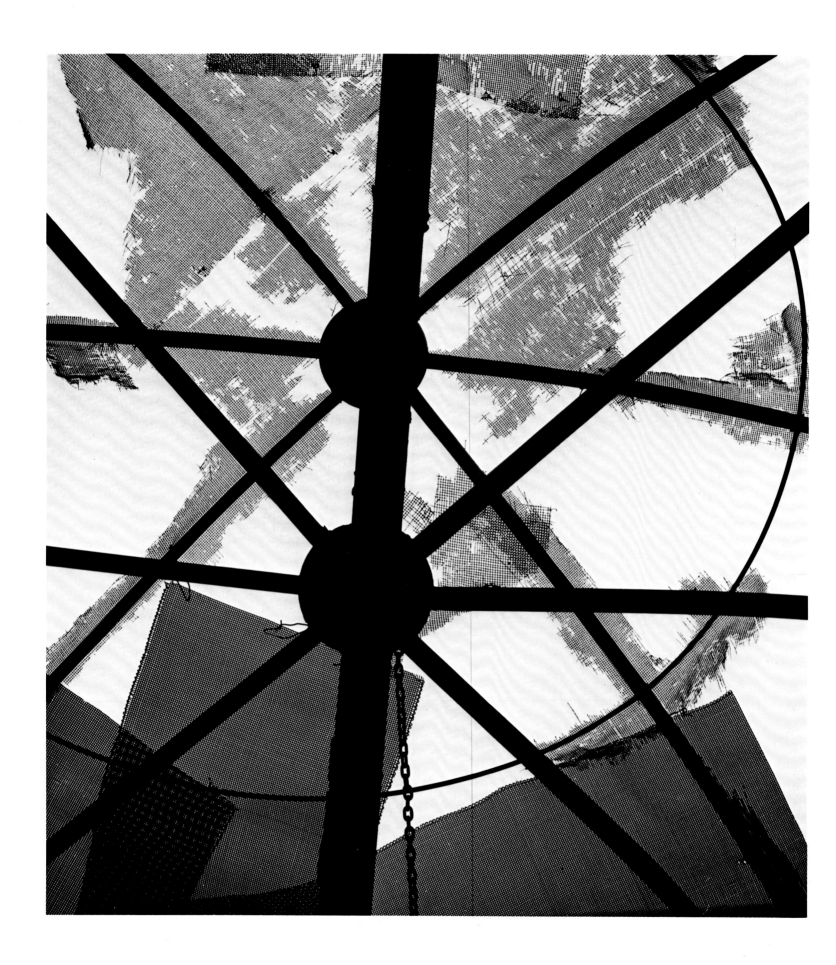

Old Wigwam Burner Slash 1971

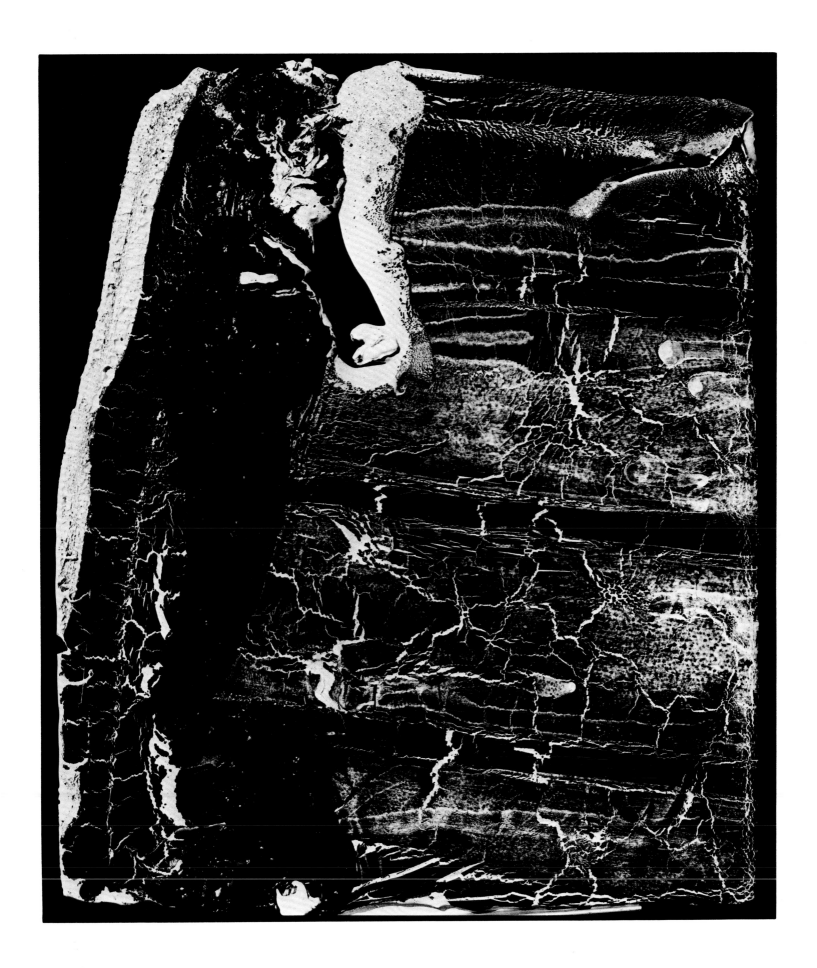

Burned Linoleum 1972

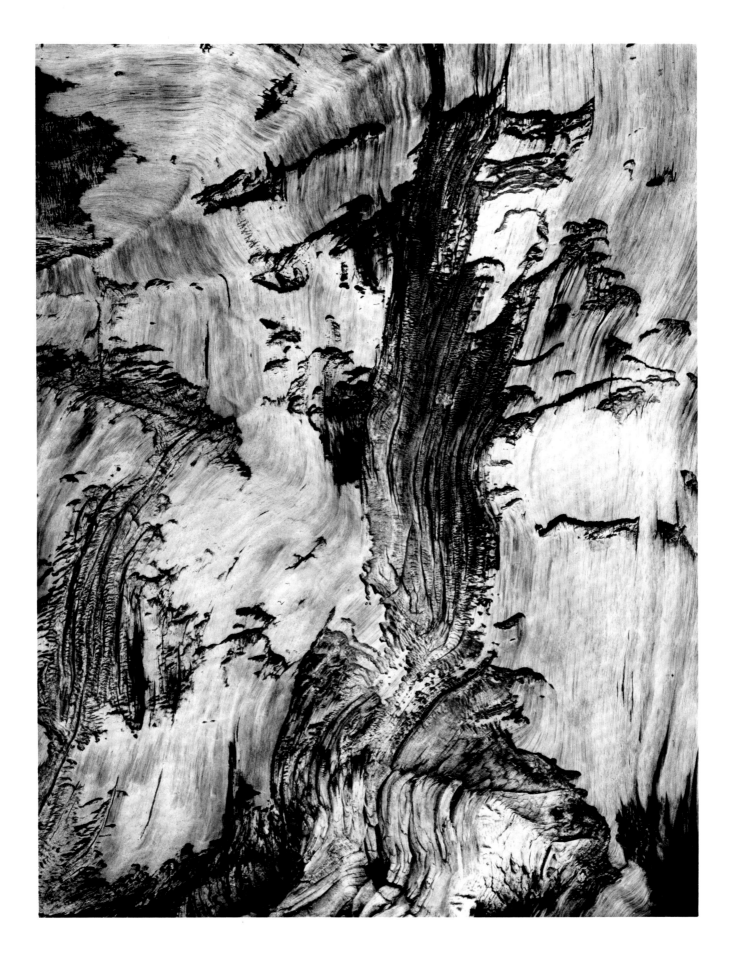

Bristle Cone Pine Bark

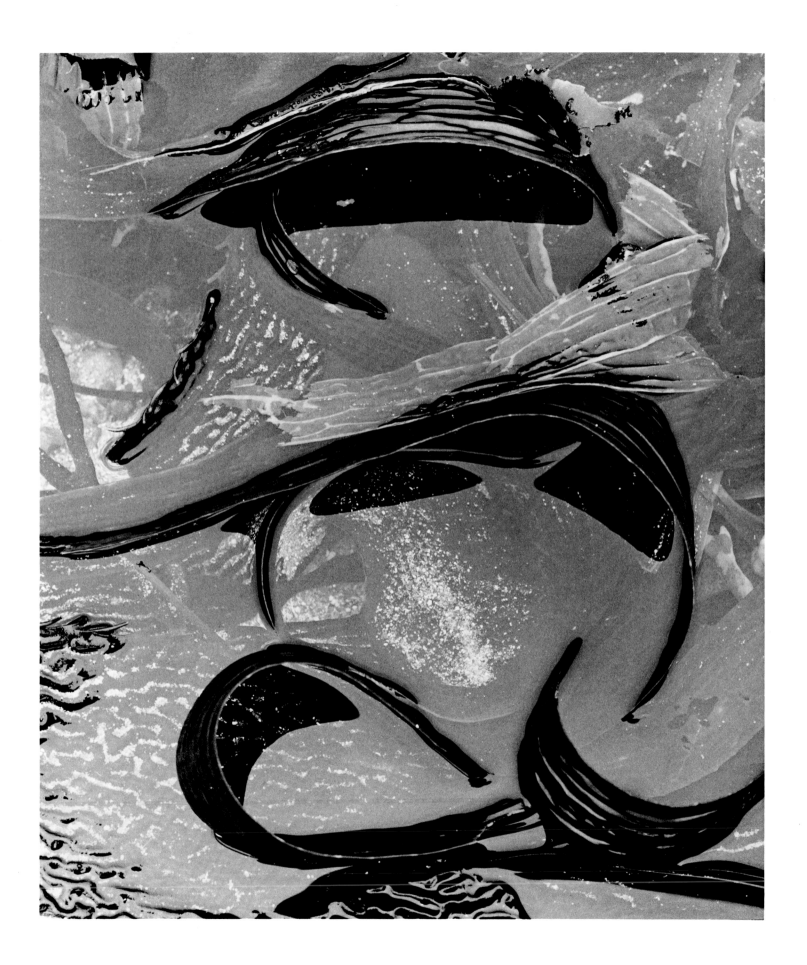

Tide Pool, Point Lobos

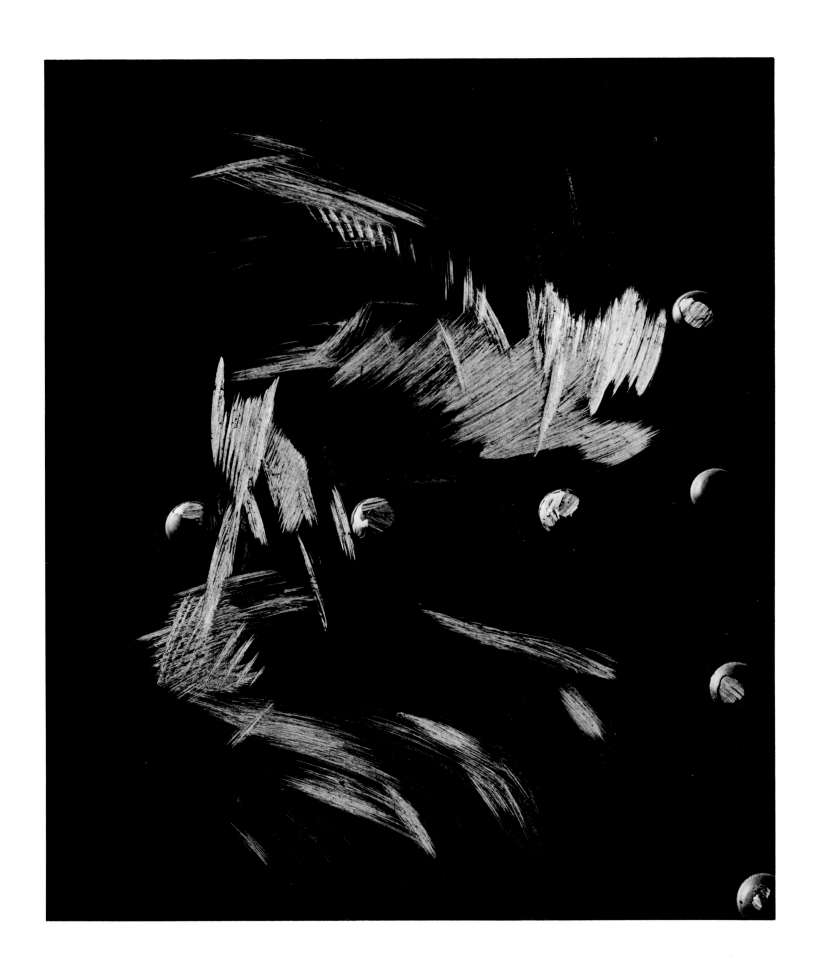

Abrasions 1975

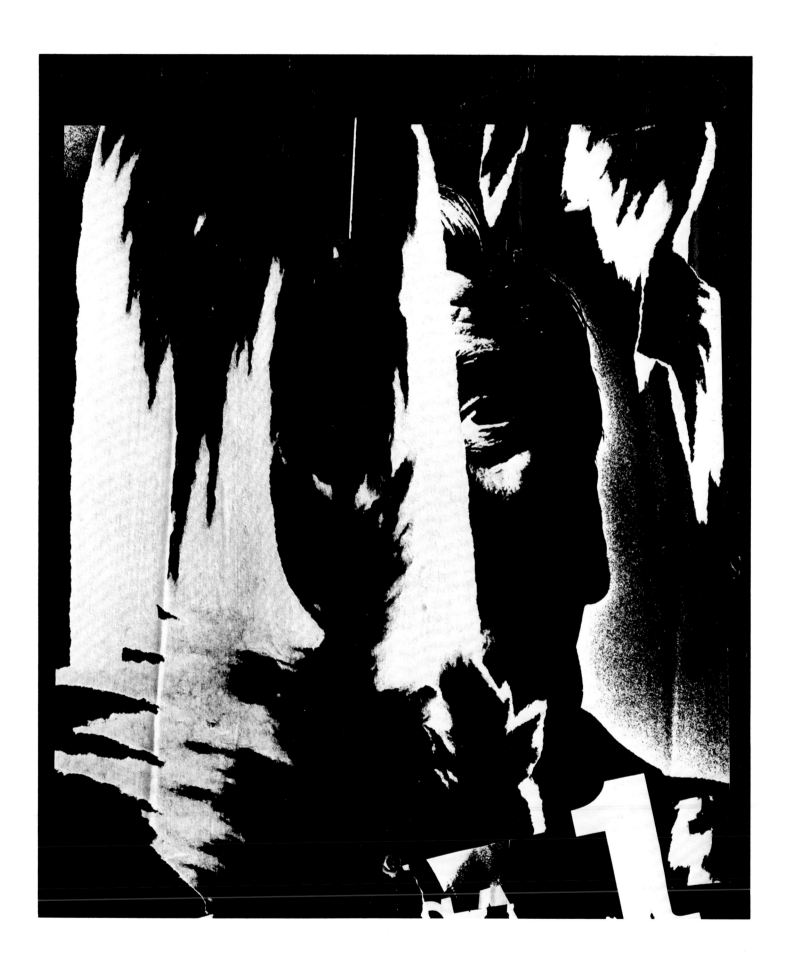

Torn Poster, The Netherlands 1971

VI

Where icy and bright dungeons lift
Of swimmers and their lost morning eyes,
And ocean rivers, churning, shift
Green borders under stranger skies,

Steadily as a shell secretes
Its beating leagues of monotone,
Or as many waters trough the sun's
Red kelson past the cape's wet stone;

O rivers mingling toward the sky
And harbor of the phœnix' breast—
My eyes pressed black against the prow,
—Thy derelict and blinded guest

Waiting, afire, what name, unspoke,
I cannot claim: let thy waves rear
More savage than the death of kings,
Some splintered garland for the seer.

Beyond siroccos harvesting
The solstice thunders, crept away,
Like a cliff swinging or a sail
Flung into April's inmost day—

Creation's blithe and petalled word
To the lounged goddess when she rose
Conceding dialogue with eyes
That smile unsearchable repose—

Still fervid covenant, Belle Isle,
—Unfolded floating dais before
While rainbows twine continual hair—
Belle Isle, white echo of the oar!

The imaged Word, it is, that holds
Hushed willows anchored in its glow.
It is the unbetrayable reply
Whose accent no farewell can know.

Continuing Work

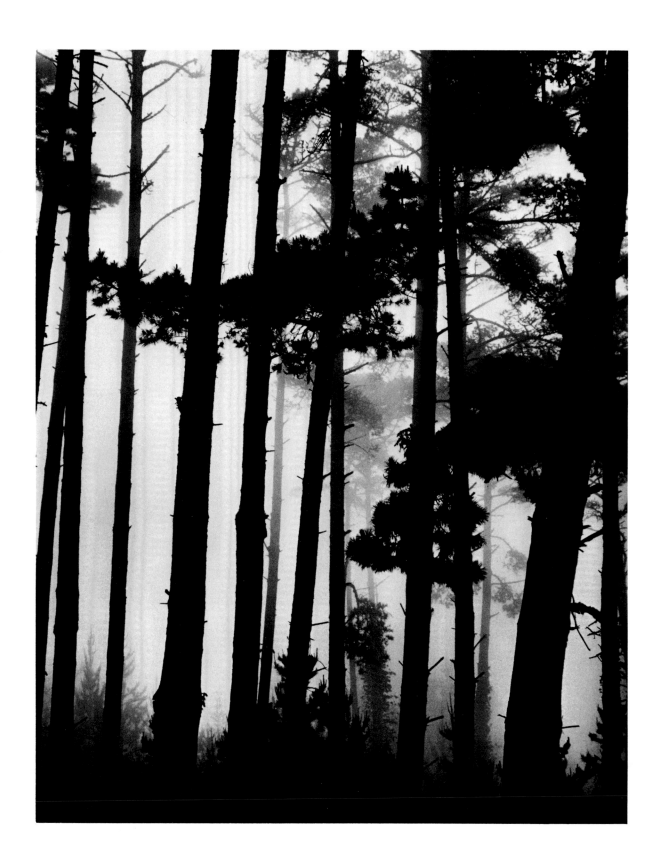

Monterrey Pine and Fog 1962

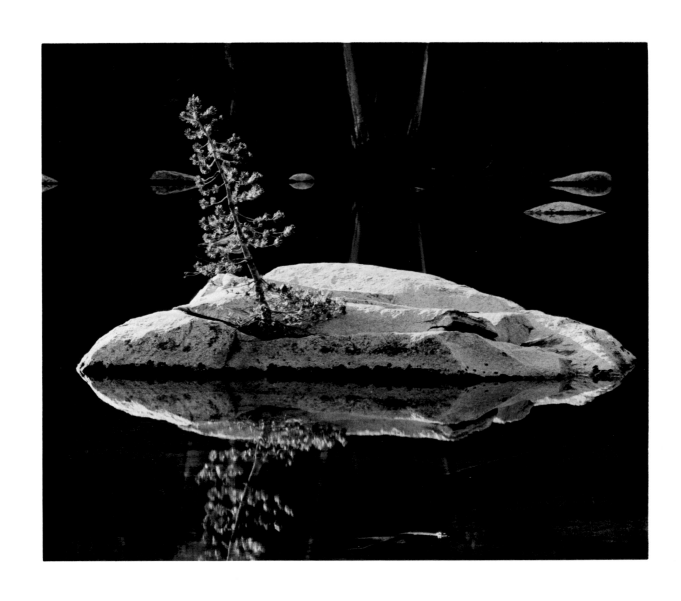

Pond, High Sierra 1971

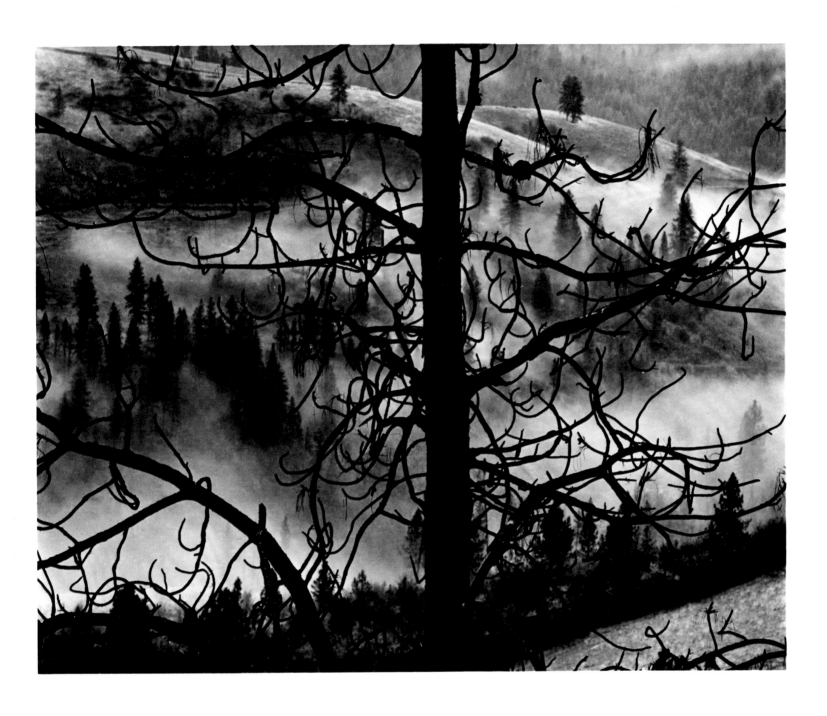

Pine Trees in Rain, Oregon 1972

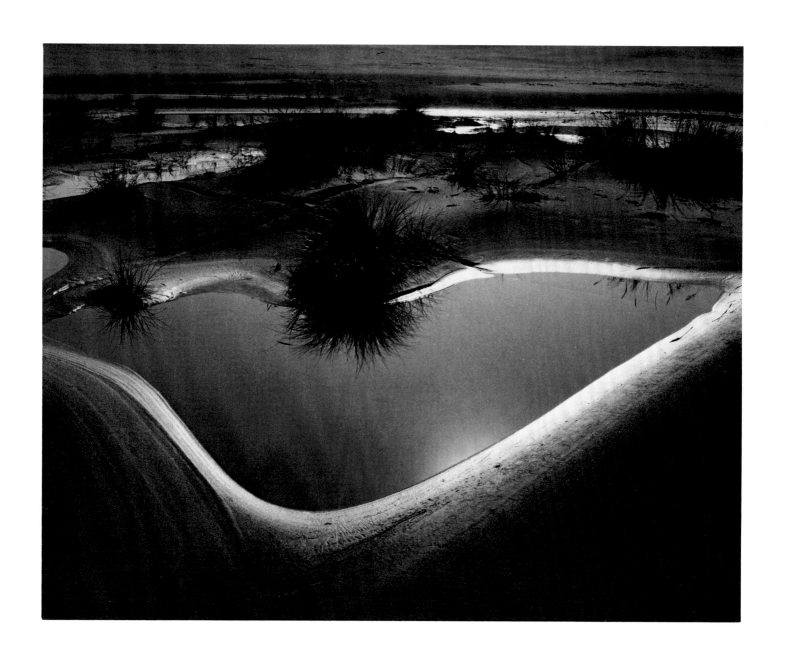

Tide Pool, Oregon 1972

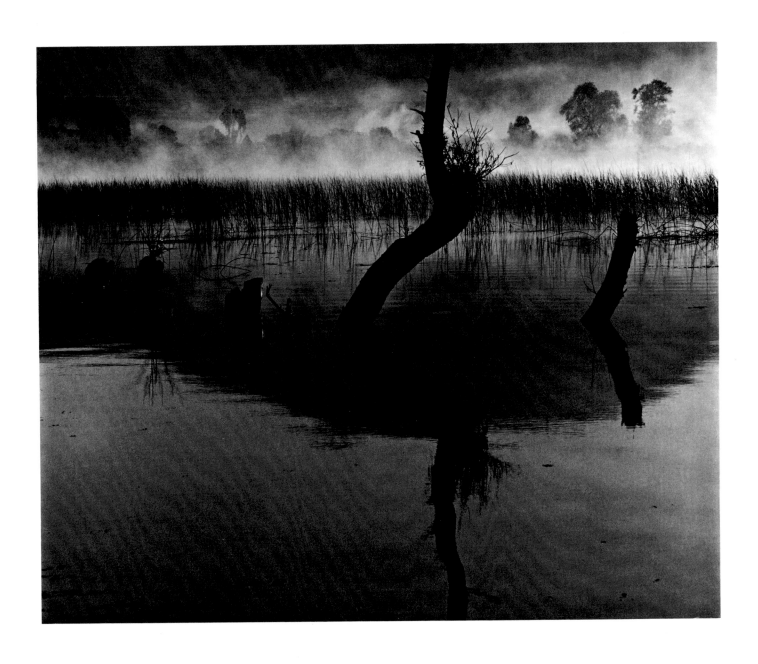

Lake in Mist, Mexico 1973

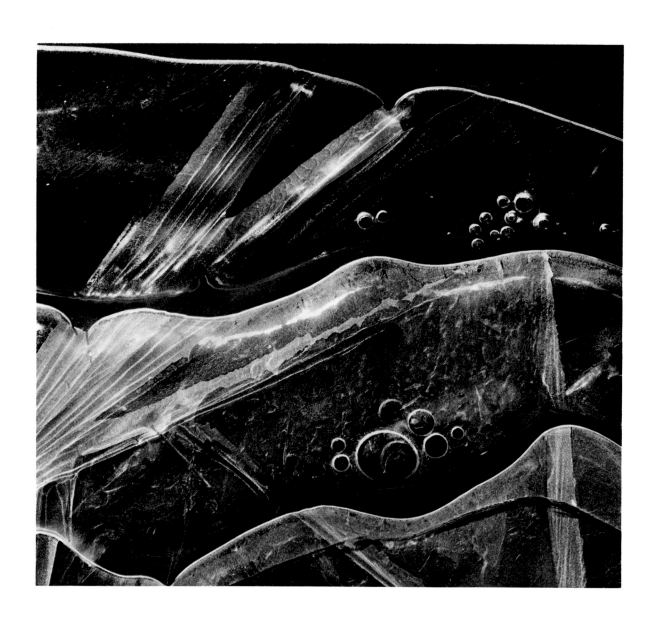

Ice Forms, Oregon 1970

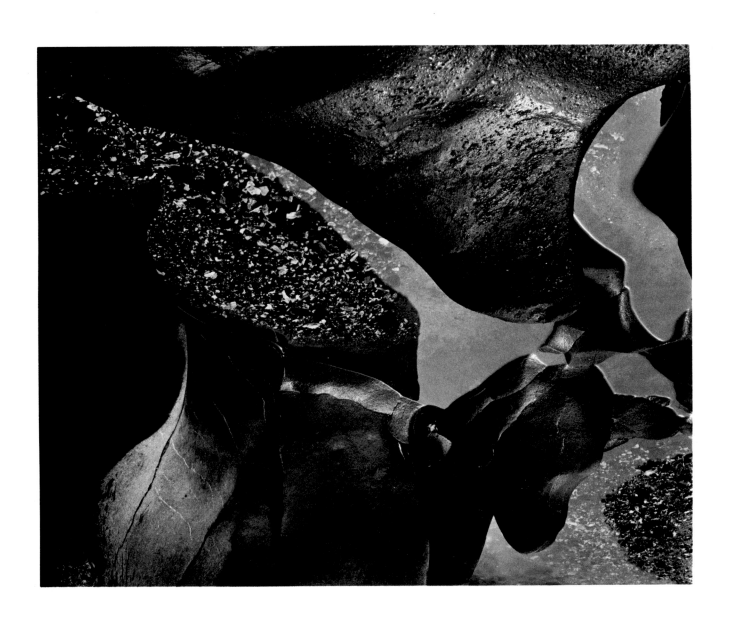

Tide Pool, Oregon 1974

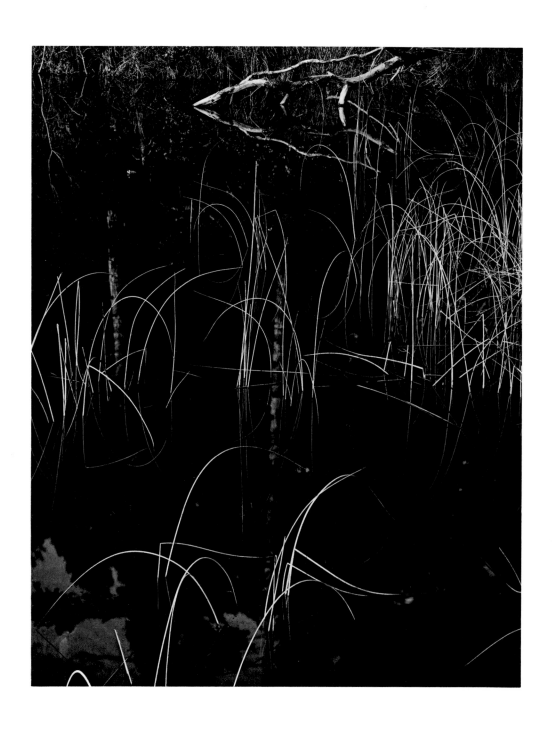

Logging Pond, Oregon 1972

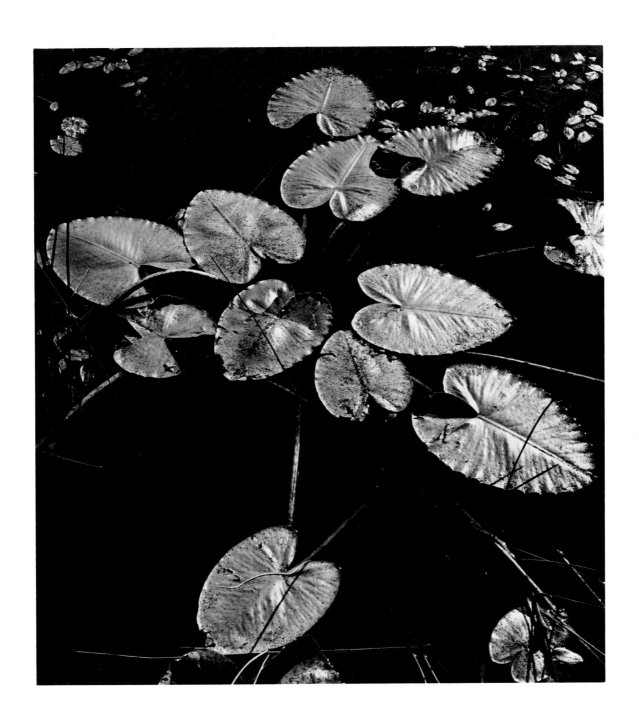

Swamp—Lily Pads, Alaska 1973

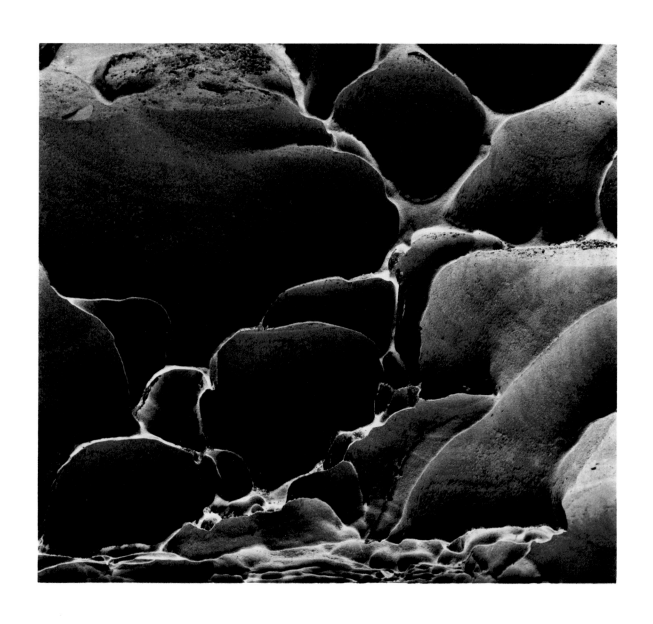

Rock Forms, Oregon 1970

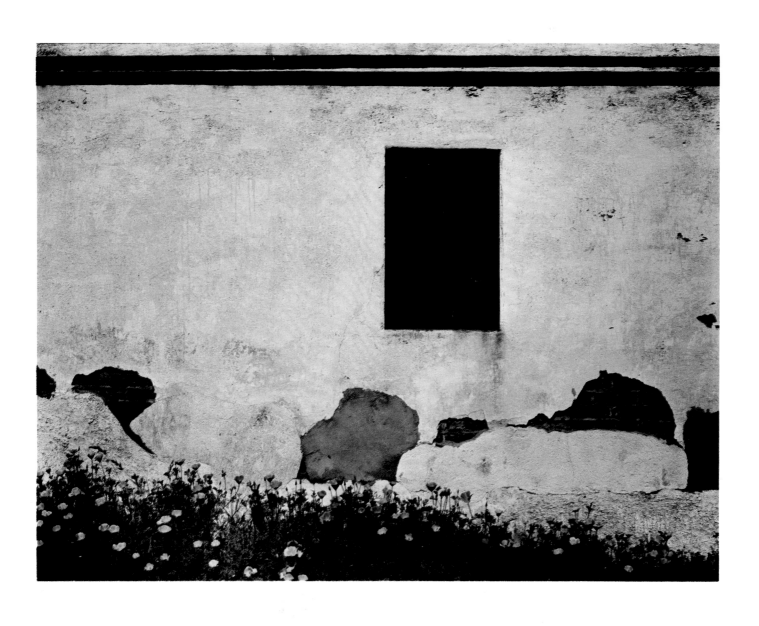

Black Window, Mariposa, California 1950

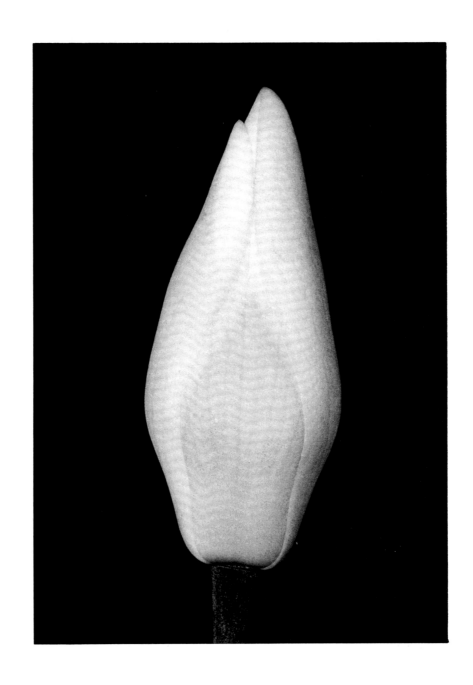

Magnolia Bud 1927

Brett Weston

"Mariposas—mariposas!" Edward Weston wrote in his Mexican Daybook on October 29, 1925, of an outing with his thirteen-year-old son. "Brett's net swishing through the air, butterflies captive in its meshes or sailing away to his chagrin. This was our day together in Tlalpan. A happy day for both, though my joy was most in his!"

Another passion soon replaced mariposas: photography. "I really got involved down in Mexico in 1925," Brett recollects. "You know I was just a boy, but I became impassioned with my first imagery on the ground glass. I saw those beautiful images and Dad simply turned me loose and said, 'Well, maybe your exposure will be thus and thus,' and so he let me alone."

Edward not only let Brett alone, but lent him his second camera, a Graflex. This superb instrument, alas no longer made and as obsolete as a Stutz Bearcat, was a reflex camera. By means of a mirror set at 45 degrees, the exact lens image was reflected on a ground glass set in the top of the camera, which the photographer viewed through a collapsible hood. At the press of a lever, the mirror was retracted, the shutter released, and the film exposed. The Graflex was for years the favorite camera of those photographers who called themselves "pictorialists" — to define their interest in producing pictures rather than records. Stieglitz made his famous photograph "The Steerage" in 1907 with a Graflex and, later, most of the great series he named "Equivalents." Edward Weston made his bold outdoor portraits in Mexico with a Graflex: "Galvan—the sharpshooter," "Nahui Olin." Brett was thus more fortunate than most youths, for unlike his father, Ansel Adams, Henri Cartier-Bresson and so many of his peers, he did not begin with an oversimplified Kodak or the cheap dollar camera Eastman named the Brownie. Instead, thanks to his father's generosity and understanding, he began with a professional, precision camera — and an expensive one (it was advertised at the time for $135).

His first photographs, as he remembers, were of a lily stalk — and a strong linear composition of a corrugated iron roof top. Edward was delighted with these simple little photographs. "With the greatest satisfaction, I note Brett's interest in photography," he wrote on November 5, 1926.* "He is doing better work at fourteen than I did at thirty. To have some one close to me, working so excellently, with an assured future, is a happiness hardly expected."

The years in Mexico were critical in Edward Weston's artistic life. He was shaping a new style in his photography. He had abandoned the soft-focus pictorial style for which he was famous and was forging a powerful direct use of the camera for producing sharp, incisive, often harsh images with emphasis on bold form and surface textures.

March 10, 1924: For what end is the camera best used? . . . the answer comes always clearly after seeing a great work of the sculptor or painter . . . that the camera should be used for a recording of *life*, for rendering the very substance and quintessence of the *thing itself*, whether polished steel or palpitating flesh.

*All quotations by Edward Weston are from his Daybooks.

Edward had simplified his technique in those formative years in Mexico. For most subjects he used an 8″ x 10″ view camera, securely fixed upon a tripod. With this classical camera the photographer, his head beneath a black cloth, focused on a ground glass. When he was satisfied with the image, he capped the lens, put a holder containing the film in the place of the ground glass, pulled out the slide that protected the film from the light, set the shutter and made the exposure. This took several seconds for even the most experienced photographer, and in that time the image he had seen might change greatly.

With the Graflex, thanks to its mirror arrangement, the camera was blind for only a split second. Edward reserved this second camera for portraits and other spontaneous work. Sheet film was used in both cameras, and these were developed one by one, in a pyro solution in a tray. Exposure time was based on experience, and intuition, not only because there were no reliable exposure meters in those days, but especially because Edward disliked interrupting the creative flow by mechanical calculations.

Oct. 6, 1924: "With a stand camera, my hand on the bulb, watching my subject, there is a coordination between my hand and brain: I *feel* my exposure and almost unconsciously compensate for any change of light."

The negatives were usually printed on platinum or palladium paper. Unless an enlarged internegative had first been made, the platinotypes and palladiotypes were the size of the negative. The paper, although expensive and difficult to keep, was the preferred medium of most pictorialists who worked in the tradition of the Photo-Secession.

Brett absorbed this seemingly simple technique with remarkable speed. As Nancy Newhall wrote in her introduction to the *White Sands Portfolio,* he "became a photographer as naturally as breathing." He even suggested variations of technique, particularly in the substitution of glossy bromide paper for platinum and palladium. "I was actually using glossy paper before Dad was, strangely enough. He had it for proof paper down in Mexico, and he used it for small commercial jobs—an occasional thing. His work was then all done on platinum matte paper. Well, I got hold of this glossy paper and loved it. I told Dad 'I like this better than platinum.' I was a pretty outspoken kid, you know, and he was very responsive to what I said."

In September 1926 Edward and Brett left Mexico and returned to California. So pleased was Edward with Brett's rapid growth as a photographer that when the University of California invited him to show in February 1927, he included twenty of Brett's photographs, and when he moved to San Francisco in 1928 to open a portrait studio there, he took Brett along as his professional partner. He noted that Brett "does most of my developing now, and does it well." It was a relief to Edward to have someone share the demanding routine of the portrait studio on which he depended for his living. And it was a joy to have Brett as a companion, when they could afford time from the business, on field trips doing what they called "personal work."

The first one-man show was given to Brett by the Jake Zeitlin Gallery in 1928; but of even greater importance was his first international recognition, at the age of seventeen, when twenty of his photographs were shown at the influential exhibition "Film und Foto" in Stuttgart, Germany, in 1929. This mammoth exhibition, which put on display more than a thousand photographs and daily screened avant garde films that are now considered classics, was organized by the Deutsche Werkbund, the most progressive art society in Germany, if not in Europe, in the 1920's. The Werkbund fostered the most daring of modern architecture. In 1927 it persuaded the city of Stuttgart to commission the architects Walter Gropius, Le Corbusier, J. J. P.

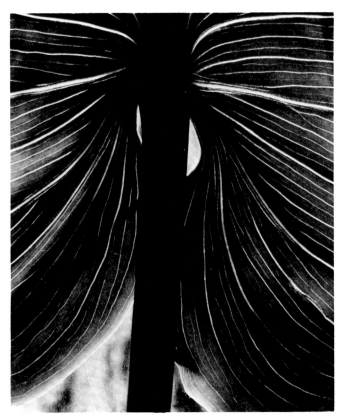

Lily Leaf, Carmel 1930

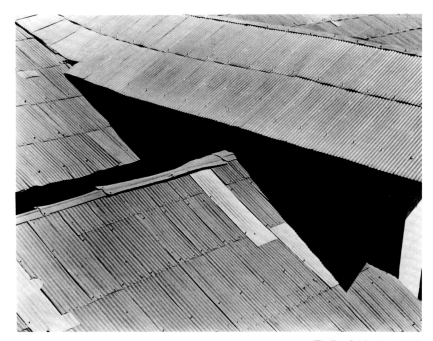

Tin Roof, Mexico 1925

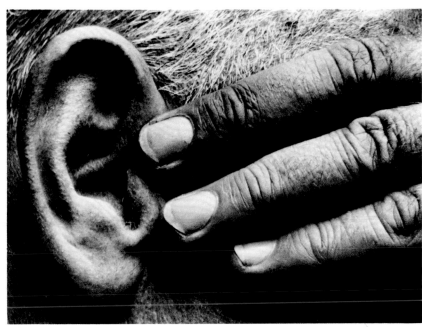

Ear and Finger 1930

Oud and Mies van der Rohe—the founders of the International Style—to build permanent housing for the Weissenhof Housing Exposition.

With equal vigor and seriousness of purpose, the Werkbund invited leading photographers and filmmakers to contribute to a demonstration of the aesthetic potentials and social significance of photography. In contrast to the many exhibitions in Germany which featured weak, academic pictorialism, it presented photographs made with a functional understanding of the medium. The organizing committee asked Edward Weston and Edward Steichen to select American work. Besides their own photographs and those of Brett, they chose work by Berenice Abbott, Anton Bruehl, Francis Bruguière, Imogen Cunningham, Man Ray, Paul Outerbridge, Charles Sheeler, Ralph Steiner and Roger Sturtevant.

Already Brett had brought to his photography that strong sense of form that has always been a mark of his style. He found much subject matter in industry—the drive shaft of a locomotive, a corrugated roof of a shed, sewer pipes. He delighted in plant forms. An extreme close-up of a hand beside an ear so delighted the Russian film director Sergei Eisenstein that he smilingly walked away with it when he saw it in Brett's studio. Edward had anticipated that his son's work would be admired in Europe, and so it was. The photographs were widely reproduced in periodicals; the tin roof was selected by Franz Roh for his book *Foto Auge (Photo Eye)*, based on the exhibition.

Another important event took place in this year: Edward bought Brett his first camera, a 4″ x 5″ Graflex, secondhand, for $50. Not until 1930 did he own an 8 x 10: it was a gift from his mother.

Edward had separated from his wife, and was now living with Brett in Carmel, California. There they discovered Point Lobos, that strange and very beautiful peninsula, now a state preserve. There they both made some of their finest photographs. Brett recollects that the rocky cove on the southwest side—for years called Weston Beach by their friends—he discovered while his father was away on a trip. He prepared a surprise exhibit of photographs of sculptured rocks and pebbles. Edward was overwhelmed:

> *Oct. 27, 1929:* When I returned from the north, Brett had an exhibit of his work—all new, and some I had not seen, hung in the studio. I can say without hesitation that he is now one of the finest photographers in this country—which means the world.

Brett still remembers this generous appreciation:

"Dad was such a big person that he said to me once, which is pretty amazing as I look back upon it now, 'You have influenced me, also.' And he also said I was his best audience, because I loved his work, appreciated it." Both grew in stature from this close association: their vision merged in an extraordinary way. But such a life could not last: Brett had to find his independence. And in May 1930, Edward wrote, "He had to spread his wings and fly! . . . So today I am both happy and sad." A few days later he photographed on Point Lobos:

> *May 24, 1930:* Toward evening I . . . made one negative, a cypress, a fine one. Not till I focussed did I realize, recognize, that I was using one of Brett's details, an insignificant bit—at first glance—which he had glorified, used in one of his best-seen negatives. Brett and I were always seeing the same things to do—we have the same kind of vision.

In 1932 Brett was given a one-man exhibition at the M. H. De Young Memorial Museum in San Francisco—his first major retrospective. He was also invited by Group f/64 to show in their exhibition at the

same museum. This informal society had been founded by Ansel Adams and Willard Van Dyke to encourage straight photography and in protest against the weak academic pictorialism and the lurid theatrical costume pieces of William Mortensen that were being widely shown by camera clubs and in photographic magazines. Edward Weston lent his support to the Group: other members, besides Adams and Van Dyke, were Imogen Cunningham, John Paul Edwards, Sonia Noskowiak and Henry Swift.

Besides photographing, Brett was making sculptures in wood of a highly original abstract nature. Not enough of this aspect of Brett's creative work has been publicly seen; the carvings are as delicately seen and as superbly crafted as his photographs. For a while he was employed as a sculptor on the Public Works of Art Project. The director of the South California region was Merle Armitage, impresario, author, connoisseur of the arts, book designer. He was an old and faithful friend of the family, and the champion of both Edward and Brett. In reviewing the second show of Brett's work at the Jake Zeitlin Gallery in 1930, Armitage wrote perceptively: ''Perhaps had he not been born the son of Edward Weston, one of the great artist-photographers of our time, he would have been a painter, or a designer and engraver of wood blocks. But always he had known the camera.''

The forms in his sculptures were based on his experience in photographing, particularly the spectacular sand dunes at Oceano, near Santa Barbara, where he was then living. His brother Chandler first discovered the photographic possibilities of these dunes, and all the Westons worked there: some of Edward's most classic pictures are of the ever-shifting, wind-swept sands. Brett's are linear, two-dimensional, taken when the sun was low and the raking light created dramatic contrasts of deepy richly black shadows and dazzling highlights. It is as though he unconsciously felt that he could better extract and express the solidity of the dune forms in his wood sculpture, and their linearity in his photographs.

In the years of the great depression Brett was, for a while, supervisor of the photographic section of the Federal Arts Project, training, criticizing and overseeing the work of twenty photographers. This was followed by work for the public relations department of the Douglas and North American Aircraft corporations.

During World War II he was in the army—from 1943 to 1946. It was a trying experience for him: he went through basic training three times, learned to drive a six-by-six truck and to be a soldier. His photographic talents were overlooked by the military establishment. Finally, toward the close of the war, he was assigned to the Signal Corps, and sent to Astoria, L.I., for yet another period of training — to learn photography! Fortunately, his superior officer, Lieutenant Arthur Rothstein, formerly of the Farm Security Administration's photographic project, was most understanding. Fully aware that he had under his command a gifted and skilled photographer, he gave Brett routine assignments to photograph New York City. These Brett accomplished quickly and easily, and spent his spare time making creative photographs with his 8 x 10 camera. The loan of an 11 x 14 view camera led him to purchase an old secondhand one — such mammoth cameras have long been obsolete since the introduction of precision enlarging equipment. ''I was simply thrilled with the enormous image size,'' he recollects. ''It's a cumbersome and unwieldy thing, not much depth of field, and it leaked and all, but I used it for twenty years sporadically, primarily just for a change of pace. My main camera has always been the 8 x 10 most of my life.''

The New York photographs are unlike any of those we had seen before. There are vast panoramas—roofscapes as it were, taken from high perches, and close details—what you see, if your eyes are acute, from the sidewalk. There are few people in these photographs, but humanity is everywhere. He photographed the trees and vines growing within the architecture, rooftop gardens, and the great striding Brooklyn Bridge. He also made many photographs in the Botanical Gardens.

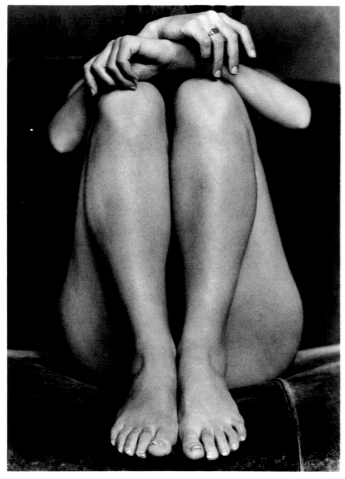

Nude 1930

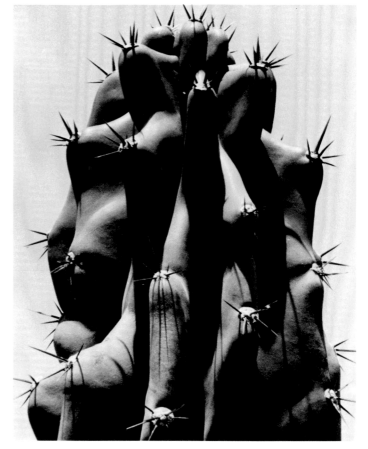

Cactus 1932

Brett was ordered to El Paso, Texas, late in 1945, and while there began to work in the White Sands National Monument. After his discharge from the army he continued to explore this majestic area as the project of the Post Service Guggenheim Fellowship he had been awarded. Twelve of the photographs were published in a portfolio with an introduction by Nancy Newhall. "Instead of abstract sculpture," she wrote, "he saw a magic play of light: grasses, ghostly in their winter death, shadowing the massive, luminous dunes with silver, the spikes and bells of yucca black as jet against them. He saw the delicate aerial structure of eerie plants reaching into the skies, the dunes gray with storm or gleaming with snow against dark distant mountains—endless absorbing variations!"

In 1956 Merle Armitage designed a handsome book of superb reproductions of twenty-eight photographs, made for the most part since 1946. In the foreword, written at the time abstract expressionism was at its height, Armitage emphasizes the relation of Brett's work to so-called nonobjective art. "Focussing his camera on his elected mise-en-scène—a tidepool, a piece of splintered glass, the eroded bark of a tree, a wind-swept sand dune or other secrets of nature—Brett produces an abstract result which should provide the key to persons who have as yet found the work of nonobjective painters an unknown and alien world. For here are the patterns, the arrangements, the designs and the evocations sought by the finest abstract painters, captured perfectly intact, and presented with the brilliance and the pristine quality which only photography can command."

The 1950's were sad years for Brett and his brothers: Edward was suffering from Parkinson's disease, and was no longer able to photograph. Brett helped his father produce his *Fiftieth Anniversary Portfolio* in 1952: twelve photographs in an edition of one hundred. Twelve hundred photographs to be printed, mounted, spotted, signed, numbered, slip-sheeted and boxed.

When friends—who still wish to remain anonymous—made it possible to select from his lifework some eight hundred of his finest negatives, Brett dropped everything and devoted all his time to the colossal task of making eight prints of each negative. So close had been their long association that Edward proudly put his initials on the mounts beneath each photograph of the master set. It was his last contribution to posterity. He died peacefully on New Year's Day, 1958, at Wildcat Hill.

Around 1960 Brett built, with his own hands and the help of friends and his brothers, a simple yet elegant house in Carmel Highlands, where he now lives. It was designed by his friend Don Ross, architect and photographer, and beautifully combines living quarters and work area. It serves as his base for his extensive travels. It is likely that he has covered more miles, always photographing only that which speaks to him and fairly demands his attention, than any other photographer not on assignment from the once lavishly generous picture magazines. He calls whichever conveyance he has chosen—panel truck, Volkswagen bus, camper—his "camera car"; it is also his home for the trip, fitted out and provisioned like the cabin of a yacht, so that he is completely independent of motel and restaurant.

In 1960, with a thousand sheets of film and his cameras, he made his first trip to Europe; in a Volkswagen bus, he covered the British Isles and the Continent: Scotland, England, Portugal, Austria, Greece—never to record the famous monuments, storied villages, celebrated landscapes, but only whatever he found challenging in form and texture. It has been said that it does not matter where Brett is, it is what he finds. Norman Hall, picture editor of *The Times*, was his host in London; he told me, in some surprise, that of all the sights he showed him, Brett found nothing to photograph until they came to London Bridge, and there a patch of rusted, flaking iron brought him to use his camera.

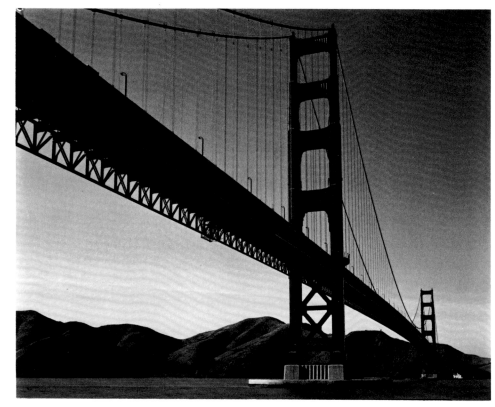

Golden Gate Bridge 1938

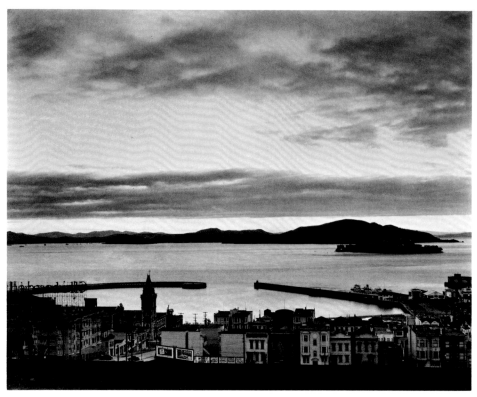

San Francisco Bay 1937

In all, five trips to Europe, seven to Baja California, innumerable trips to Oregon and the Northwest, a brief visit to Japan, and now, for the third time, Alaska.

For years the 8 x 10 was Brett's preferred camera, with occasional use of the mammoth 11 x 14, and rare use of the 5 x 7, which he called his "Minicam." The Graflex, which he used for portraits, he now found unwieldy, and the ground glass difficult to see, so he bought a 2¼ x 2¼ twin-lens reflex camera, a Mamiyaflex. He found that with modern precision enlargers, he could make enlargements of sufficient sharpness to meet his high standards. In Germany, touring as the guest of the government in 1968, he saw in the Rolleiflex factory one of their new single-lens reflex cameras, their newest model—and in short supply. On his return to the States, one of these cameras, with a battery of lenses, was made available to him. He has found it not only an ideal second camera, but a new tool which has expanded his work.

"It gives me a flexibility that I don't have in a big camera, also its superb optics on the ground glass. The finder system is so brilliant that I can see in the very dark areas without a focusing cloth and I can get things instantly when I am tired or after a long day. The camera can be swiftly set up. I use it almost entirely on a tripod with the exception occasionally of people when I hand-hold it. I use it primarily as a small view camera. Of course it has the front swings and bellows all there, which is very important for me. I use two lenses mostly, the 120 mm and the 250 mm. They are fairly extreme. But I have the 80."

In his recent work there is a boldness and surety—the great sweeping rhythms demand the 11 x 14 size to which he enlarges the Rolleiflex negatives.

When we visited him in June 1973, he had just returned from Alaska, where he had been on a trip sponsored by a grant from the National Endowment for the Arts. New, fresh prints were on the wall. An artist is always, rightfully, proudest of his latest work, and the critic is often embarrassed at not being able to share the artist's enthusiasm. But now there was no such problem: the prints sang. One in particular, a view of a glacier breaking up, moved me. I said to Brett: "Your work over the years has shown two directions. First, a great interest in form for its own sake, almost regardless of content, usually linear and flat. Then, secondly, the grand landscapes, which fairly involve the spectator in space, and depend upon the subject. Now, somehow, you've combined these two qualities. That picture of the glacier could be considered abstract—"

"Yes. It is," Brett said.

"But there it is, exactly the way it was and as you saw it, and you have brought us to the spot where you stood. It seems to me that this powerful duality, this combination of the abstract, in the emphasis upon form, and the sense of presence, in the rendering of light and substance, is something only photography can do."

"And it does it magnificently," Brett replied.

Beaumont Newhall

Chronology

1911 Theodore Brett Weston born, December 16, Los Angeles, California.

1925 Went with Edward Weston to Mexico for two years. Made first photographs.

1927 Lived with Edward Weston in Glendale, California. Helped with father's portrait business and had prints exhibited along with Edward's in 1927 in Los Angeles.

1929 Moved with Edward Weston to San Francisco, then to Carmel. Opened studio with Edward.

1930 Left Carmel alone and moved back to Glendale. Set up own studio. Married first wife, Elinore.

1930–31 Moved to Santa Barbara and set up studio.

1932 Had first major one-man show at M. H. de Young Museum, San Francisco.

1935 Worked with Edward for one year in Santa Monica.

1936 Moved to San Francisco and met second wife, Cecily.

1938 Only child, Erica, born, January 11.

1940 W.W. II: Left San Francisco with Erica and settled in Santa Barbara. Worked in aircraft factory.

1941 Drafted.

1943 Stationed in New York. Began work with 11 x 14 view camera.

1946 Discharged.

1947 Received post-service Guggenheim to photograph up and down East Coast.

1948 Returned to Carmel and stayed on to help ailing father. Built studio-house along with brother Cole at Garrapata Creek, ten miles south of Carmel.

1950 Married third wife, Dody, Edward Weston's last apprentice.

1952 Printed Edward Weston *50th Anniversary Portfolio* with help of Dody, Morley and Frances Baer, and Cole.

1955 Printed Edward Weston *Print Project* under Edward's supervision. Divorced from Dody.

1958 Built current home in Carmel Highlands.

1959 Glen Canyon trip.

1960 First of five trips to Europe.

1964 First of many trips to Baja California.

1968 Guest of German government on cultural exchange program. Exhibited in many major German cities. Sponsored by Rollei-Werke, who provided their SL-66 2¼ SLR for his use.

1970 Major exhibit of 150 prints at Friends of Photography, Carmel. Broke all attendance records.

1970 Photographed in Japan. Married and divorced fourth wife, Tina.

1973 Awarded grant from National Endowment for the Humanities to photograph in Alaska.

Selected Bibliography

Books and Periodicals

Aikin, Roger, "Brett Weston and Edward Weston: An Essay in Photographic Style." *Art Journal*, 32, no. 4 (Summer 1973), 394–404. 12 illus.

Amon Carter Museum of Western Art, *Brett Weston Photographs*. Introduction by Nancy Newhall. Fort Worth, Texas, 1966. 40 pp., 33 illus.

Armitage, Merle, *Brett Weston Photographs*. New York, E. Weyhe, 1956. 92 pp., incl. 28 plates, size of 8″ x 10″ originals.

"Brett Weston." *Aperture*, 7, no. 4 (1960), 136–50. 11 illus. Without text.

Newhall, Beaumont and Nancy, "Brett Weston." In their *A Collection of Photographs*. New York, Aperture, Inc., 1969, pp. 32–33. 3 illus.

Parella, Lew, "Brett Weston." *U.S. Camera, 1956,* pp. 238–43.

[Thompson, Dody Weston], "Brett Weston, Photographer." *American Photography,* 46, no. 9 (Sept. 1952), 32–39. Published under by-line "Dody Warren."

Turner, David G., "Brett Weston Alaskan Photographs." *Popular Photography,* 75, no. 1 (July 1974), 111, 180.

[Weston, Charis Wilson], "Brett Weston, Photographer." *Camera Craft,* 47 (Mar. 1940), 113–22. 8 illus. Published under pseudonym "F. H. Halliday."

Portfolios of Original Photographs

San Francisco. 10 photographs. San Francisco, 1938.

White Sands; a Portfolio of Ten Original Photographs. Foreword by Nancy Newhall. Typography by Grabhorn Press. Carmel, California, 1949.

New York, Twelve Photographs. Foreword by Beaumont Newhall. Typography by Adrian Wilson. Monterey, California, 1951.

Fifteen Photographs. Carmel, California, 1961.

Twelve Photographs. Carmel, California, 1963.

A Portfolio of Photographs of Baja California. Fifteen photographs. Carmel, California, 1967.

Fifteen Photographs of Japan. Carmel, California, 1970.

Europe: Twelve Photographs. Foreword by Gerald Robinson. Typography by George Beltram. Carmel, California, 1973.

Oregon. Fifteen photographs. Foreword by Bernard Freemesser. Typography by George Beltram. Carmel, California, 1975.

Motion Picture

Brett Weston: Photographer. Produced and directed by Art Wright, with the aid of a National Endowment of the Humanities grant. Production assistance: Stephen Wagner, Bernard Freemesser and George Beltrau. Produced 1972, revised 1974. Distributor: Art Wright, Pocatello, Idaho.

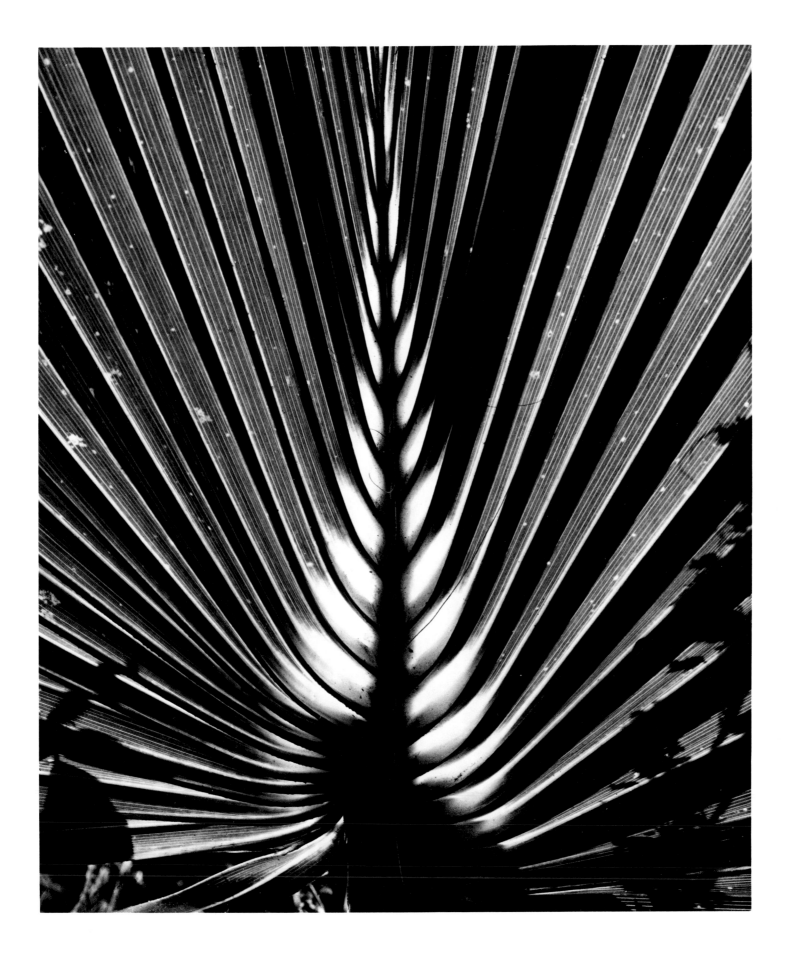

Palmetto, Mexico 1973